Angel CRAFT

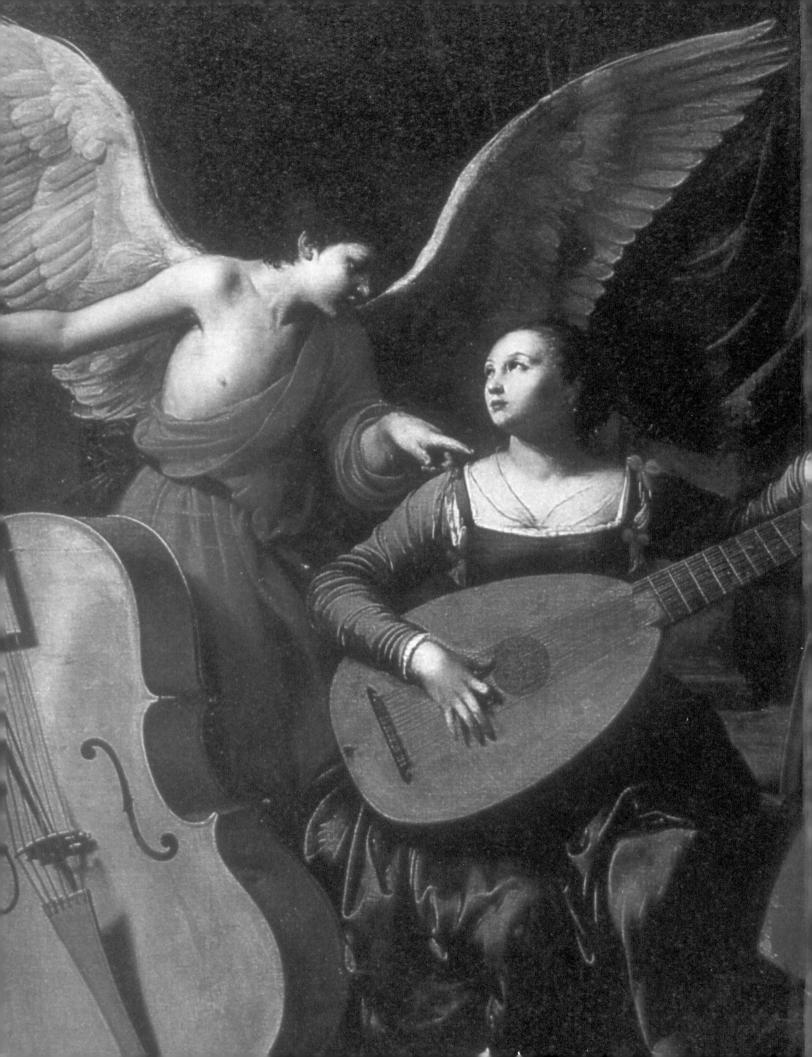

Angel CRAFT

A heavenly collection of thirty angel projects,
from papier-mâché to needlecraft

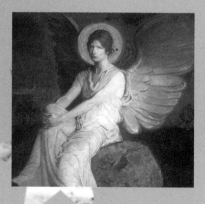

LINDA BARKER

Project Maker SALLY BARKER

CHARTWELL
BOOKS, INC.

A QUARTO BOOK

Published by Chartwell Books Inc.
A Division of Booksales, Inc.
114 Northfield Avenue
Edison, New Jersey 08837

This edition produced for sale in the U.S.A.,
its territories and dependencies only.

ISBN 0-7858-0665-2

This book was designed and produced by Quarto Publishing plc,
The Old Brewery, 6 Blundell Street, London N7 9BH

Designer: ANNIE MOSS
Mac artist: JOHN FOWLER
Senior editor: GERRIE PURCELL
Editor: ANNA SELBY
Art editor: CATHERINE SHEARMAN
Photography: RICHARD GLEED
Illustrations: ELSA GODFREY
Picture researcher: MIRIAM HYMAN
Art director: MOIRA CLINCH
Editorial director: MARK DARTFORD

Typeset in Great Britain by Type Technique, London
Manufactured in Singapore by Eray Scan Pte Ltd, Singapore
Printed in China by Leefung-Asco Printers Ltd, China

Other project-makers
The publisher would like to thank the following
for their contributions to the book:
Petra Boase for *Angel in Frame* (pp.104-05), and *Appliqué Pillow* (pp.106-08);
Charlotte Gerlings for *Lace Angel* (pp.63-65), *Victorian Angel* (72-73),
Cross Stitch Angel (81-83), and *Baby Angel Rag Dolls* (pp.94-99);
Deborah Schneebeli-Morrell for *Repoussé Tin Foil Angels* (pp.100-101) and
Paper-Cast Angel Medallions (pp.109-111).

CONTENTS

This book brings to you a collection of Angels – Angels that have been crafted in salt dough, fabric and mosaic; Angels that have been appliquéd, stenciled, painted or découpaged. These are but a few of the craft techniques we show you how to perfect in this heavenly book. If the idea of an Angelic quilt or painted lampshade appeals to you, then this is the book for you. Angels for your bedroom, kitchen, or children's rooms – there is something for everyone. If you want to make a special gift, then this book is an endless source of inspiration.

We are sure you will enjoy the huge range of crafts we have collected here for you – we hope you find our Angels a rewarding and uplifting theme.

Linda Barker
and Sally Barker

Introduction

Heavenly History

Techniques

Victorian Angels

Folk Angels

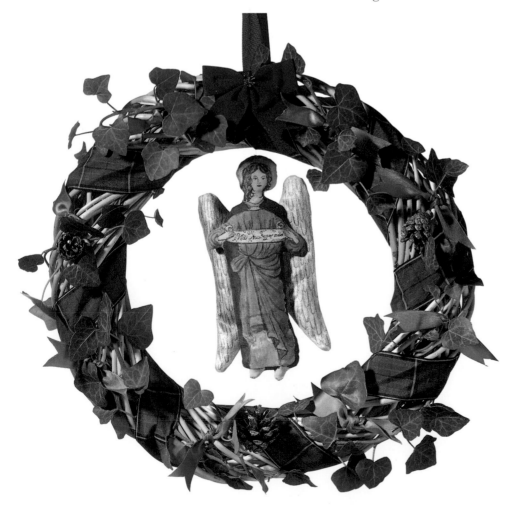

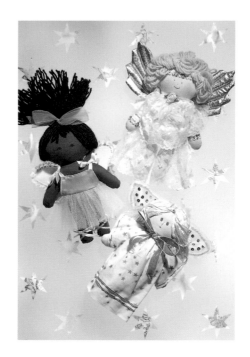

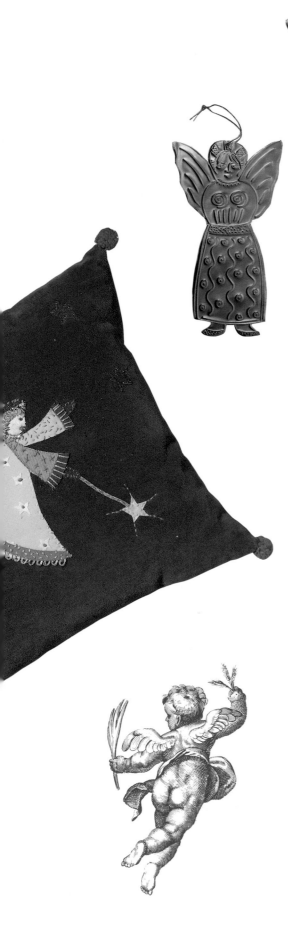

Contemporary Angels

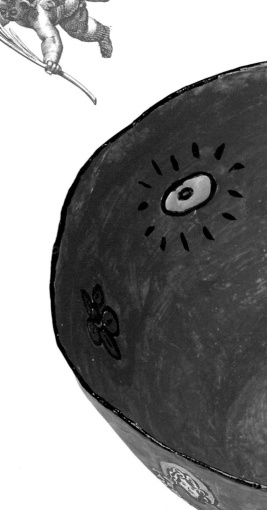

Introduction

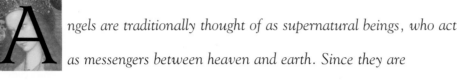

ngels are traditionally thought of as supernatural beings, who act as messengers between heaven and earth. Since they are considered to be disembodied, descriptions even by those who claim to have seen them are necessarily imprecise, and representations of them have altered dramatically down the centuries. The Angel's significance as a messenger is important in many of the world's great religions. For example, in the Old Testament of the Christian Bible, which is based on Hebrew scripts, the Angel of the Lord calls to Abraham when he is about to sacrifice Isaac, and Jacob also dreams of Angels ascending and descending a ladder between earth and heaven, the very expression of their status as ethereal messengers.

From Genesis, the first book of the Old Testament, onward, the scriptures suggest that there is a hierarchy of angels, with the most highly placed Angels watching over Eden, and more lowly angels assigned to guard nations and human beings. This idea was taken up in around A.D. 500 by the Christian mystic Dionysius, and later influenced Thomas Aquinas's Summa Theologiae leading to much debate concerning the nature of Angels. The Angels were classified in nine orders of three ranks each. In the first rank were the most privileged who could know and see God; in the second rank were those who could know God through the contemplation of the principles underlying Creation; in the third rank were the Principalities, Archangels, and Angels, the farthest from God, who knew Him only through His

BELOW
St. Michael the Archangel, leader of the celestial armies, was adopted as the warrior patron of the Holy Roman Empire. This painting by Hans Memling, entitled *The Archangel Michael* (c.1480), shows the Archangel holding his sword in a more serene pose than the usual militant attitude struck by many of Memling's contemporaries.

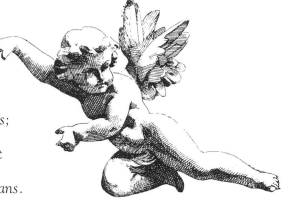

creations. It was they who were concerned with human affairs: Principalities looked after nations; Archangels appeared to individuals at significant moments; and Angels were our personal guardians.

In the Middle Ages, when few could read, the Church depended heavily on art to communicate its message, and the bodiless, immortal spirits described by St Thomas Aquinas were given form by the artists of the day. Their Angels frequently bore halos - a symbol of purity - and wings.

The earliest known depiction of a winged Angel is a fifth-century mosaic in the Church of St. Prudencia in Rome. The wings emphasized the

BELOW
Images of childlike Angels, or cherubs, have been popular in art since the Renaissance period.

LEFT
For centuries, painters have depicted Angels and cherubs as participants in human events, and actively influencing human lives.

Angel's role as messenger: the word "angel" comes from the Greek for

messenger. Greek and Roman mythology and art also portrayed winged

gods in human form: Thanatos, the god of death, and Hermes the

messenger, and also Eros, the god of love. More closely related to

the Biblical Angels, however, are the divine messengers of

Babylonian and other Near Eastern religions. Islam likewise

assigns an important role to Angels, and the Angel Jibreel (Gabriel),

bedecked with 140 pairs of wings, brought the Qur'an to Mohammed.

RIGHT
Since the Middle
Ages, especially
during the
Renaissance
period, Angels
have been
depicted as
beautiful, graceful,
creatures in
winged human
form.

The Angels of early Byzantine art were huge

bearded human figures with enormous wingspans. But

during the Crusades (11th to 13th centuries), they

began to reassume human proportions, and with them

human attributes, even acquiring armor in their fight against evil.

During the Middle Ages, in the attempt to bring religion into ordinary

people's lives, Angels were linked more closely to everyday

existence, and they were shown performing their role as warriors

or messengers in recognizably domestic settings. The early 14th

century saw the beginning of a lasting association of Angels with

music, and soon Renaissance artists began to adopt Angels with

unparalleled enthusiasm. Probably our best known images of

Angels come from this

period. Paintings by Van Eyck,

Raphael, Leonardo Da Vinci, and

Michelangelo, among others,

feature them in forms ranging from

graceful, exalted, heroic youths to

more rounded feminine forms and,

for the first time, the childlike,

wide-eyed Angels with colored

wings and tousled hair.

The Reformation of the early

16th century made Angels familiar

human helpers again — more like

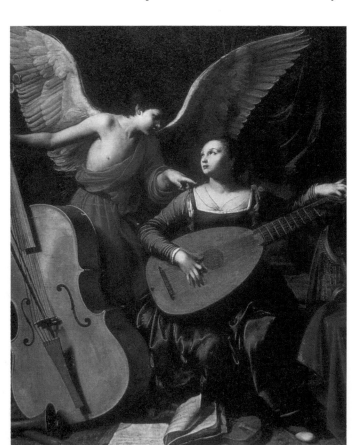

TOP LEFT
A depiction of
Eros, mending
"arrows of love."

ABOVE
During the Middle
Ages, stained glass
windows depicted
Angels involved in
religious events to
help teach the
illiterate in the
congregation.

LEFT
Carlo Saraceni's,
*St. Cecilia with an
Angel* (c.1660),
shows the patron
saint of music
accompanied by
an Angel.

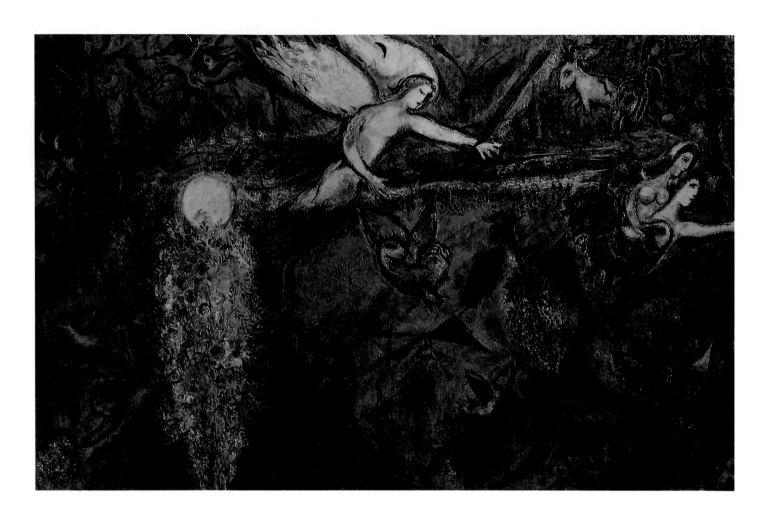

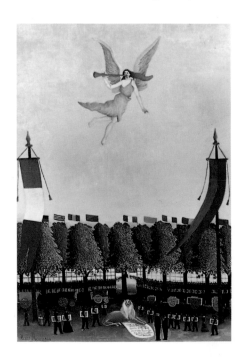

good neighbors than mystic beings — and the Counter-Reformation re-emphasized their militancy. But their closer association with human beings also brought a move to depict them in more sensual terms. Gradually they became reduced to somewhat frivolous ornamental figures on the margins of religious art. The Age of Enlightenment and the advent of skepticism almost swept them from the scene altogether, but they were retrieved by the pre-Raphaelite painters of the 19th century, who sought a return to the spirit of the artists before Raphael. They reinstated the solemn youths of earlier times and blended sensuality and purity in their wingless angels.

ABOVE
Chagall's *Adam and Eve out of Paradise*, shows an Angel helping to dispell them from Eden.
(Musée Nationale, Nice)

LEFT
Rosseau's 1906 painting shows Liberty as an Angel calling artists to participate in an important exhibition.
(National Museum of Modern Art, Tokyo).

Greater literacy, and the spread of the printed image, brought a spate of popular interest in the Angel. The Victorians adopted them for children, for whom the Guardian Angel became an important protective figure.

In modern times, some cultures still acclaim their particular Guardian Angels – as they give hope in an insecure world. Angels have recovered their role as links between the earthly and the spiritual – and also as a metaphor for understanding the world of electronic communication. Some modern philosophers view them as an image of the disembodied but intimate connections that take place across the global network – the latest manifestation of the enduring power of the Angel as a symbol for every age.

LEFT
This painting by Martin Delahano, entitled *Some Were Lifted Up, Others Saw Visions Come To Be*, depicts the Angel's role in the Last Judgement.

Techniques

PHOTOCOPIES

Throughout the book, you will find a number of projects that make use of either black and white or color photocopies, and, for certain projects, they are invaluable.

Angel imagery can be found in many places – engravings, lithographs, prints of Old Masters' paintings, calendars and illustrations, to name a few. The photocopier means we can use all of these images without having to cut up valuable old books or destroy favorite postcards or prints.

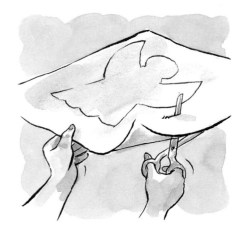

Black and white photocopies can be made quickly and inexpensively. Most shopping areas have a photocopier available for the general public, and certainly one should be available for use in most libraries. Dark and light tones can be altered simply and effectively at the press of a button, sizes can be enlarged or reduced to suit a particular project and, of course, multiple images are produced easily. Color photocopies cost a little more than the black and white copiers. However, with a carefully selected image the results can be worth the expense – making color copies is infinitely preferable to cutting up books or catalogs. Black and white images can be used in a color photocopier to produce interesting one-color tonal prints. Black and white copies may also be tinted using colored crayons or watercolors.

1 Use a color or black and white photocopier to reproduce the required number of prints you will need for your project. Brush over a layer of sealant to prevent the printing inks from bleeding at a later stage. You will need to buy a watercolor, charcoal or pastel fixative (or spray adhesive) for this. A small bottle of clear liquid fixative (or can of spray adhesive) can be bought from an art suppliers or good craft shop. After a few minutes, the sealant will be dry and you can start to cut out the motif.

2 If you need to cut out the photocopy from the backing paper, firstly make a hole. Using the point of your scissors, cut into the center of the paper, slightly away from the outline of your motif. Remove the scissors and replace them into the cut from underneath the paper. You will find it is much easier to cut out your image in this way, as it is possible to see where the blade is cutting. Use a small pair of curved cuticle scissors if you have them, and turn the paper rather than your scissors for a more precise cut.

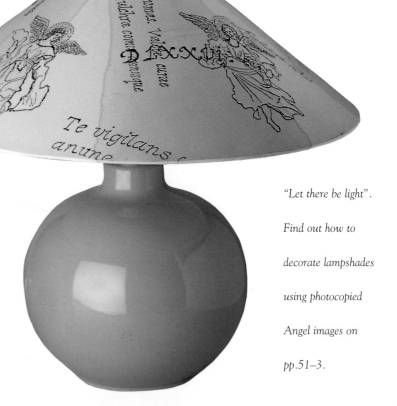

"Let there be light".

Find out how to

decorate lampshades

using photocopied

Angel images on

pp.51–3.

DÉCOUPAGE

Découpage is the art of assembling paper cut-outs, and there is great scope for this type of applied decoration. Almost any surface can be decorated with paper cut-outs – from ceramic and glass to furniture and walls. The cut-outs themselves can be photocopies, pages of an illustrated diary, sheet music, old calendars and wrapping paper, even pages cut from a magazine. Unlike many crafts, the materials for découpage are likely to be found in your own home, and additional finishing materials, such as varnish, are relatively inexpensive.

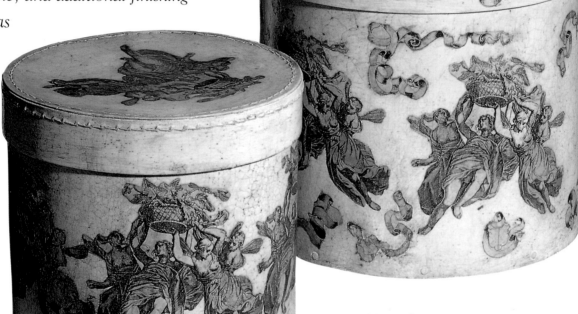

One important rule is to use only paper that is printed on one side, otherwise you may get a ghosted image of the print on the reverse after the varnish has been applied. Usually, you will need to paint a background color onto your object before applying découpage. Most surfaces require only two coats of latex paint although certain surfaces require specialist products such as red oxide metal primer if you are decorating tin or metalware. Découpage allows even people who believe they had no creativity at all to have a try without feeling intimidated – and often produce spectacular results.

1 Assemble your images together onto their surface until you are satisfied with the arrangement. There are two ways of fixing the cut-outs onto the surface. You can paste the back of the cut-out, then place it onto the surface. Alternatively, you can glue the surface itself and press the cut-out on top, removing any excess glue with a damp sponge. For more intricate cut-outs, the second method is more reliable, but test it out yourself to see which you prefer.

Many ordinary items can be made to look stylish using découpage. These hatboxes are excellent examples – see pp.48–50.

2 Eliminate any air bubbles by gently rolling your fingers from the center outwards, across the freshly glued cut-out. Wet your fingers slightly with cool, clean water before you start, as this will help to avoid tearing the paper. If your fingers become sticky, rinse them as you go along. Once the cut-outs are firmly fixed in place, any excess glue should be removed using a rolling movement across the whole surface with a small damp sponge. Rinse the sponge as the glue builds up, if necessary.

3 Check your work by tilting it against a light source – this could be either daylight or lamp. This will show if all the glue has been thoroughly removed and that there are no air bubbles under the surface. At the same time, check that everything is firmly stuck down and no part of the design lifts from the surface. Allow to dry completely, preferably for 24 hours.

This attractive

trinket box

(see pp. 42–3)

mixes découpage

and golden

geometric designs to

great effect.

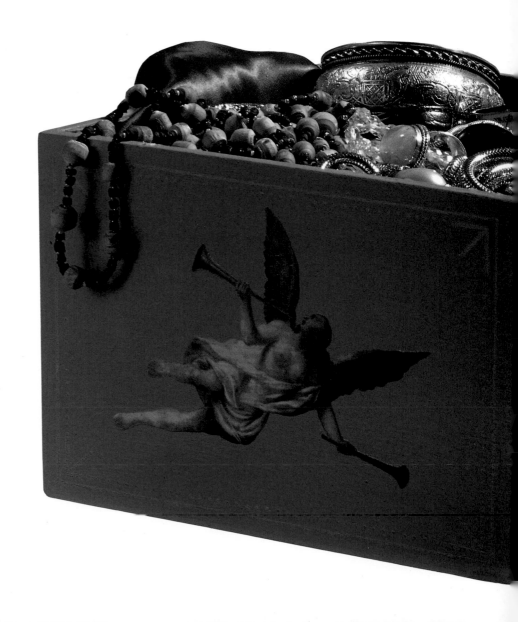

4 Remove all traces of dust using a damp lint-free cloth. Stir the varnish – do not shake the container as this adds air bubbles – apply a thin coat and leave to dry. The drying time depends on conditions in the room, and if you are using acrylic, water-based varnish or spirit-based, polyurethane varnish. Water-based varnish has the advantage of being quicker drying, and brushes may be washed in water. Polyurethane varnish is harder wearing and can bring an "antique" patina to the project due to its slightly yellowing coloration after several coats.

★★★★★★

Always allow the previous coat of varnish to dry completely before applying the next. The more layers of varnish you apply, the better the end result. The aim is to lose the cut edges of the copies. The thicker the paper onto which the copy was made the more coats will be needed. Purists of découpage insist that at least 20 coats are applied and sometimes more, but approximately seven to ten coats should give you a good finish.

★★★★★★

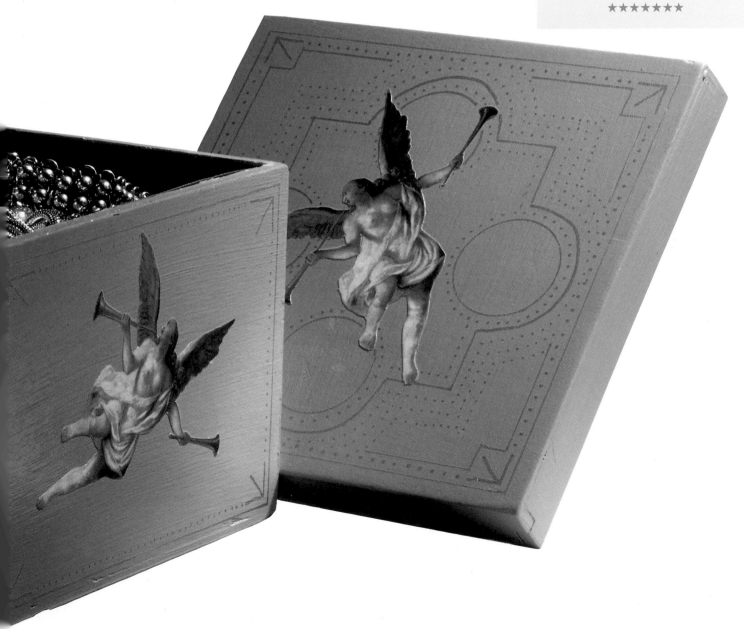

APPLIQUÉ

In appliqué, small pieces and scraps of fabric are sewn onto each other to build up an interesting pattern or picture. Working in this way, you can create a wonderful quilt, pillow or throw from old scraps and remnants that were most likely destined to be thrown away. Often small bags of scrap fabric can be bought in some fabric outlets, mainly for use in patchwork and appliqué. If you are lucky, these could include small pieces of exquisite beaded and silk fabrics along with the more common cottons and woven fabrics.

If you feel that appliqué is for you, it is a good idea to get into the habit of saving all your bits and pieces of scrap fabrics. Store smaller pieces in screw-top jars or lidded boxes. Larger pieces will store neatly in old shoe boxes. Separate the colors into their basic primary shades if you have lots of scraps. It's amazing how inspiring this methodical approach can be. Looking at jars of jewel-bright fabrics can be instrumental in starting off your next great project.

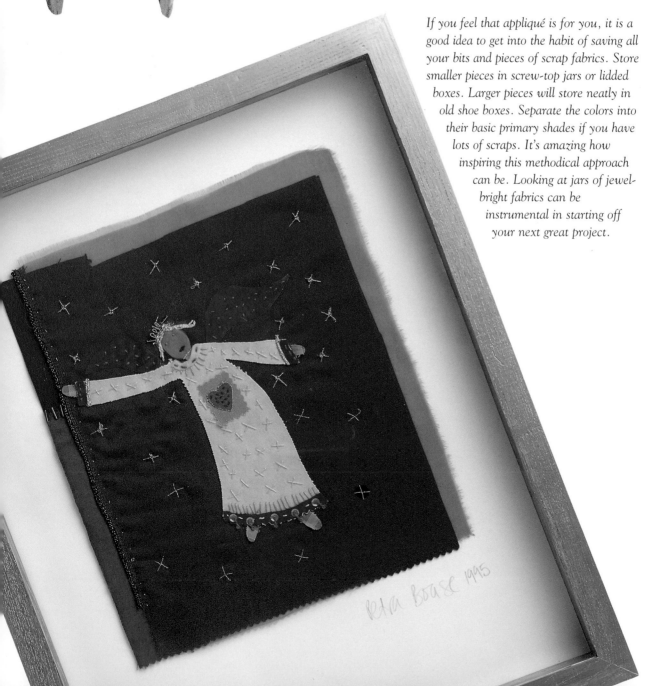

Opposite. This fun, contemporary style pillow is not only decorated with an appliqué Angel on the front, but also given a special touch by adding buttons on the back – see pp. 106–108.

This appliqué Angel in a frame would brighten any wall. See pp.104–5.

1 Select the fabrics for your project.
Delicate fabrics, such as organza and antique lace, can be used for an appliqué picture or keepsake but would deteriorate quickly if used and washed often, as part of a baby quilt, for example. Items that will require regular cleaning ought to combine printed cottons and washable fabrics. All fabrics purchased off the roll have their washing instructions printed on a care label. For scraps that you may have inherited or simply forgotten about, quickly wash these by hand first to check their fastness and shrinkage.

2 Roughly cut out the pieces for
your appliqué from the various fabrics and lay these onto your base fabric. When you are satisfied with the arrangement, hold them in place with dressmakers' pins. If you are hand stitching the appliqué, sew around all these pieces in turn, carefully tucking under a small seam allowance as you work around each shape. For machine stitching, simply select a close zigzag stitch on the machine and stitch around the various shapes. You may need to stop and lift up the sewing foot to sew neatly around any points and sharp curves in the design.

enlarging, then a photocopier may be the easiest method. Cut around the outline and pin this onto your fabric. Pin the fabric onto the base material and hold it in place with dressmakers' pins or a little fabric glue. Sew around the raw edges, as before.

3 Additional decorations can be stitched onto the appliqué. Effective notions include beads and buttons, sequins and upholstery trimmings. Different materials can alter a whole piece of appliqué quite dramatically. Embroidery stitches are also a useful technique for adding interest.

4 If you intend to make an appliqué picture, you may need to cut the precise shapes for the figures using an outline as a guide for making a template. The template is then used to cut the fabric. Trace the outline onto a piece of paper or use a photocopier if you prefer. If your outline requires

This charming crib

quilt, decorated with

appliqué Angels,

would make an

ideal gift for a new

born baby.

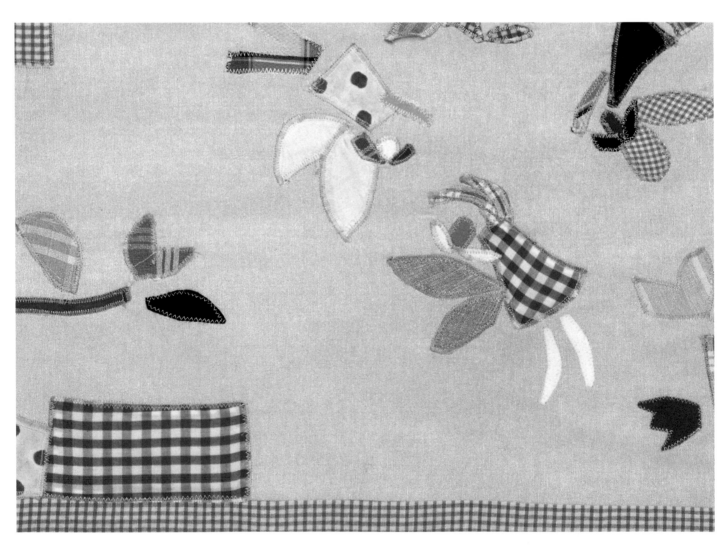

SALT DOUGH

This very versatile modeling dough is made from basic kitchen ingredients. It is simply a combination of flour and salt bound together with a little water. The proportions are two parts plain flour to one part salt.

Mix the two ingredients together with enough water to make a stiff dough. The dough may then be rolled or modeled using any technique you wish – young children particularly enjoy squashing the dough through their fingers! Then allow it to dry in a cool oven.

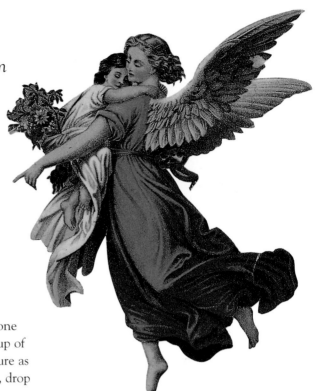

Although basic in construction, salt dough can produce some very fine results. You can make reasonably large projects with this modeling material – small bowls and wall plaques as well as smaller-modeled projects. The technique for making the dough is really very simple, and the only problems likely to occur are when the drying time has been accelerated. It is important for the dough to dry in a really cool oven – gas mark ½/130°C/ 250°F is all that is needed. Drying will take about eight hours for smaller items and up to 12 hours for anything larger. Allow the salt dough to cool while still inside the oven to reduce the possibility of cracks. Turn off the oven and leave the door slightly open. Once the dough is dry, simply paint it with water-based colors. Tempera and acrylic colors have a wonderful intensity but you could use ordinary latex paints if you wanted. As with the delightful Angel tree decorations (on pp.92–3), it is possible to achieve extremely fine painted details. Equally important though, the dried dough can stand up to whatever punishing paint treatment a young child can throw at it.

1 Mix together two cups of unbleached all-purpose flour and one cup of salt. Slowly mix in half a cup of water and start to knead the mixture as it binds together. Add more water, drop by drop, until the dough has a firm, smooth texture. Take care not to add too much water to the dough, and knead it firmly each time you add water. Too wet and it will sag.

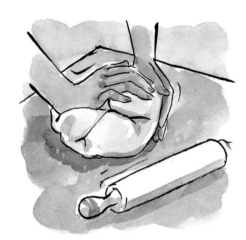

2 Remove the dough from the mixing bowl and knead it well for about ten minutes until it is perfectly smooth. Allow the dough to rest for about 30 minutes in an airtight container to prevent it from drying out. Turn the dough out and shape it. To roll it out, you may need to lightly flour your board as you would when making pastry. Roll out half the mixture at a time, keep the rest inside the container.

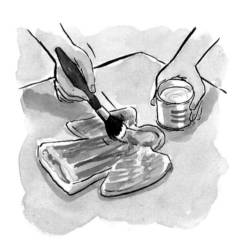

3 The salt dough may be decorated using ordinary paints and colors (see pp.92–3). The designs can be quite sophisticated, and fine details can be painted onto the salt dough surface as simply as if it were a piece of paper or board. Once the paint has completely dried, cover both surfaces with two coats of protective varnish, making sure that the first coat is completely dry before applying the second.

PAPIER-MÂCHÉ

Papier-mâché is definitely a craft that can be enjoyed by everyone. All the materials are readily available and you'll probably have everything you need under the kitchen sink. It is a perfect craft to start with if you don't want to buy any new equipment or materials.

There are two slightly different techniques. The first involves making a paper pulp which is then pressed into or around a mold and left to dry. The second method, which is the one we use in this book, is known as the layering method. It is most likely that this is the method that we all remember from our schooldays. It is a very quick and simple process and involves building up layer upon layer of pasted paper around a mold. It is possible to add all the layers at once, but it is better to allow each one to dry before applying the next. The result of this longer process is a stronger and smoother finish.

The number of layers depends on the time you are prepared to spend. You can do a minimum of three layers, but eight is ideal and ten would be even better. The end result will always be strengthened considerably with the final application of varnish.

Adhesive is important, and the strips of newspaper should be well soaked. Wallpaper paste is inexpensive and easily mixed with water, and it is perfectly satisfactory for most projects. Care must be taken, however, as it does contain fungicides, and you should protect your hands with rubber gloves. All-purpose white glue also works well for papier-mâché. It may need to be diluted with water to make it easier to work with, or mixed with wallpaper adhesive to give added strength.

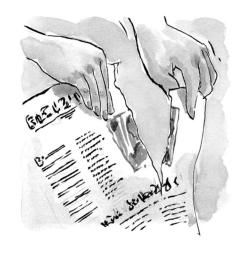

1 Tear sheets of newspaper into long strips along the grain of the paper. You may like to use alternate layers of pink then white newspaper, so you can see the layers building up evenly. For some projects, you could build up layers of colored or handmade papers. These papers wouldn't require a painted finish as the paper itself provides the decoration. Alternatively, build up most of the layers with ordinary newspaper, and then apply the final couple of layers using colored or handmade papers.

This papier-maché

bowl is painted in

Mexican-style bright

colors with simple

Angel and flower

images (see

pp.114–5)

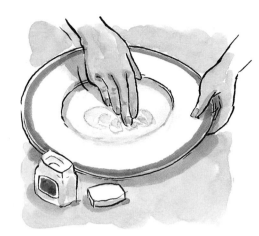

2 Soak the strips in the glue for a few minutes until they are quite flexible. While you are waiting, prepare the mold. An upturned bowl is ideal, as it provides a support as well as the necessary bowl shape. Whatever its shape, the mold must be coated with a layer of petroleum jelly, which will act as a releasing agent, to prevent the first layer of paper sticking to the surface of the bowl.

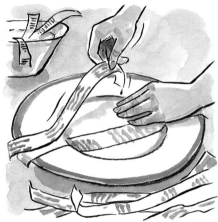

3 Apply the layers evenly, allowing each to dry before applying the next until you have reached the desired thickness. Leave the completed bowl to dry in a warm, dry place. When completely dry, simply twist the bowl in the mold. The releasing agent should help separate the bowl from the mold. Turn out your papier mâché bowl and decorate.

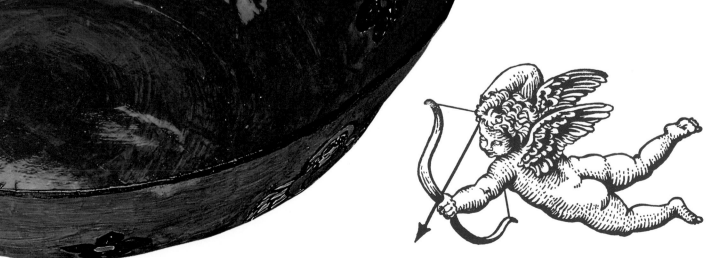

STENCILING

Stenciling is a rewarding craft to do, and you can produce a very sophisticated finish when you have mastered the basic techniques. All sorts of stencils are available from stores. Smaller, pre-cut stencils can be used to build an all-over pattern on walls, and larger ones produce a strong element of design. They can be applied onto fabrics, china and glassware with ease.

A stylized Angel design stencil was used to decorate this comforter quilt cover – the stenciled border motifs set off the whole item.

It really isn't difficult to make up your own stencils, and this means you can create exactly the stencil you want for a particular job. The materials can all be purchased from a good art suppliers. There are basically two types of stenciling cardboard. The first is the traditional oiled manila cardboard, treated with linseed oil and easily cut with a craft knife. It is tough and will withstand repeated stenciling. The second is mylar or acetate. This is a semi- or fully-transparent design film available from graphic and art suppliers. It is easily cut with a craft knife, although great care must be taken, as it can be a slippery surface. The main advantage it has over oiled manila is that you can use a heat cutter if you have one, which makes cutting stencils simple and effortless. It can also be an advantage to see underneath the stencil when re-positioning

Always use special stencil brushes when applying color. These are often round squat brushes with blunt, stiff bristles and are perfect for the job. Any other brush just isn't worth using as it can easily spoil the end result. You will generally need at least two brushes for any one job, one for the light colors and one for the darker ones – though one for each color is preferable. Craft knives need to be extremely sharp. The smaller ones are comfortable to hold, and they should always have a supply of interchangeable blades.

If you accidentally cut a design in the wrong place, stick tape over the break on both sides of the stencil, then recut, leaving a narrow strip of tape. The kind of tape depends on the type of cardboard you are using. Clear tape should be used for the transparent film, whereas masking tape is suitable for the manila cardboard.

1 Select your outline. If you are using one from this book, you may need to enlarge it under a photocopier. Cut a piece of stencil cardboard or film to size, slightly larger than the outline you are using. Fix a piece of tracing paper over the outline and draw around it using a sharp, soft-leaded pencil. Remove the tracing and draw over the outlines on the back.

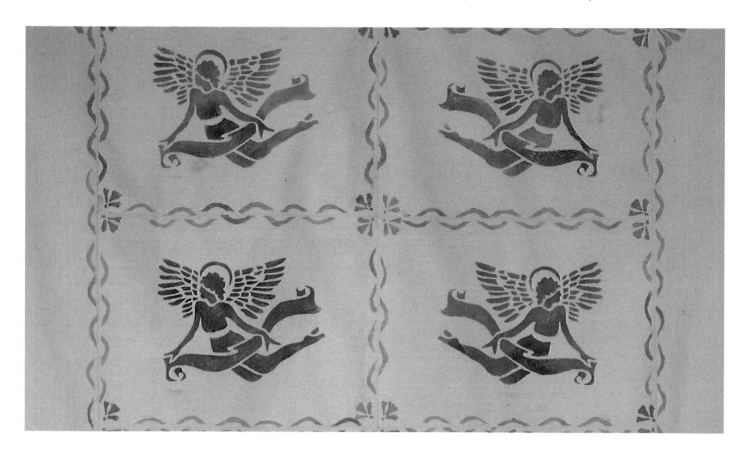

2 Place the stencil cardboard under the tracing paper, this time with the right side of the design facing up. Attach the tracing with small tabs of tape, if necessary. Draw around the outline. Remove the tracing paper and quickly go around the design once again with the pencil for a good outline.

3 Place the stencil cardboard/film onto a cutting mat. An old vinyl or cork tile will be perfectly adequate if you do not have a mat. Cut out the stencil, starting with the smaller parts of the design before the bigger areas, and working from the center outwards. Replace blunt blades as often as necessary – the cutting of a stencil becomes extremely hard work if you are working with a blunt knife. Take the cutting slowly. When the final cut has been made, your stencil is complete and ready for use.

4 It is helpful to spray a little adhesive, re-positioning spray (sometimes called spray mount or spray adhesive) onto the reverse side of the cardboard or film. This will maintain an even and secure contact between the stencil and its underlying surface. Tape or adhesive mounting pads (Blutack) may also be used, but they do not ensure as good a contact as the spray adhesive – which helps to prevent paint from seeping under the stencil.

MOSAIC

Mosaic is a fascinating craft and only basic drawing skills are needed to outline images. Putting together a mosaic picture can be like assembling a jigsaw, except that you cut the pieces instead of fitting the pre-cut variety.

There are basically two methods for producing mosaic. The direct method involves sticking the pieces of mosaic onto a hard surface with the right side of the mosaic facing up. The second, slightly more involved, technique is the indirect method, in which you lay the individual mosaic pieces face down onto an adhesive paper surface. Only when the whole mosaic is completed is it fixed in place and this sticky backing paper removed, revealing the right side of the mosaic for the first time.

For most craft projects, such as wall plaques and pictures, the direct method is the most acceptable technique and the one we use in this book.

The pieces that make up a mosaic are known as "tesserae." These can be anything from specialist glass and ceramic tiles to stones, pebbles, shells, buttons or beads. Any number of other materials could be used – it is really up to you. Most commonly, tiny vitreous glass tiles are used. These can often be bought from swimming pool specialists and are usually purchased by the sheet, although sometimes they can be sold as a mixed bag measured by weight. These tiles are perfectly smooth on the top surface and usually have a ridged surface on the back, making it easier to bed them into their grouted surface. You will also need a pair of tile nippers, available from most hardware stores.

All-purpose white craft glue and woodworking glue are both ideal for gluing the tesserae onto a wooden surface. Most wall plaques and pictures have a particleboard or wooden base.

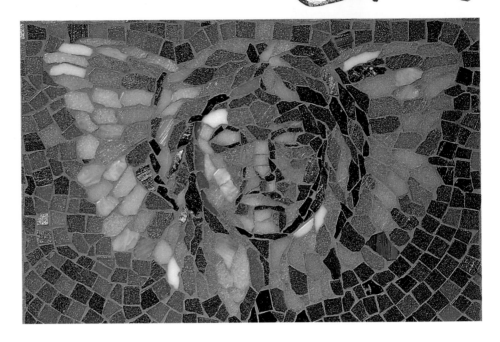

Particleboard is preferable if you are making a rounded or curved shape as it is easily and cleanly cut with a jig saw. Once the tiles are firmly adhered to their base, they are grouted to create a practical and smooth surface.

Wear safety goggles even when cutting the tesserae, as small fragments of glass can splinter off quite easily. Rubber gloves are best worn for grouting, to protect your hands from the harsh chemicals.

1 Decide on the size of your finished wall plaque or mosaic picture and cut a piece of particle board to size. Prime the board on both sides using a thinned dilute solution of all-purpose craft glue. One part water to one part all-purpose craft glue will be sufficient. Leave this to dry for about an hour.

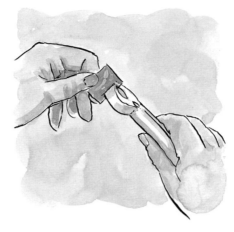

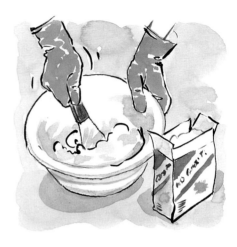

6 Put on rubber gloves and mix up a small amount of grout according to the manufacturer's instructions. Slowly pour in water until the grout is soft and malleable like a thick cake mix.

2 Draw the outline of your mosaic onto the board using a soft pencil. You can take the outline from a tracing (see the mosaic Angel wall plaque on pp.116–117) or it could be a simple outline drawn freehand. Often it is the simplest of outlines that works best. Beginners may like to do a test piece first, such as a star or sun shape.

3 "Key" the top surface of the board by scratching it with the sharp teeth of a small saw. Draw the teeth over the surface until a fine network of small scratches has built up. Hold the board secure on a work bench while you are doing this, or work on the floor and wedge the board against a solid object.

4 Start to lay the tesserae onto the board. Work from the center of your design outwards, cutting the tiles with the nippers. Hold the nippers in one hand and the small tesserae in the other hand, between thumb and forefinger. Place the cutting edge of the nippers in the middle edge of each tessera. Squeeze the nippers closed to snap the tile in half – the halves may be snapped in half again using the same technique to produce smaller quarter tiles. As you become used to the nippers you can produce any shape you require for the mosaic.

Opposite: This

colorful mosaic uses

a simple Angel face

outline as its main

design feature –

different colored tiles

can produce very

different results.

7 Fill a large trowel with grout and let the grout fall onto the surface of the mosaic. Spread it around using a rubber squeeze/sponge until there are no gaps left. Wipe away any excess with a damp cotton rag until the surface is completely clean. Leave to dry for 24 hours.

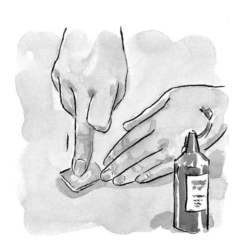

5 Smear the reverse of each mosaic piece with a little glue. Press it down firmly in place. You can cut a small pile of tesserae, then stick them down or cut and glue each one as you go – the best technique is what suits you. When the tesserae have all been fixed onto the board, leave it for about one hour for the adhesive to become really firm.

8 Wipe away the dusty layer that will have formed on the surface of your mosaic, using a damp cloth. Secure a hook or hanging plate to the back of the board to hang the mosaic.

Victorian ANGELS

CHRISTMAS STOCKING

Stockings hung up on Christmas Eve are one of our best-loved traditions. This exquisite example is simple to make, using scraps of fabric for a patchwork effect and decorated with appliqué Angels sewn with glitter thread. Over the years, this stocking may pass through successive generations, and become a family heirloom.

MATERIALS

★ 22 × 15in (56 × 38cm) red corduroy for the stocking
★ colored scraps of fabric in damask, silk or brocade for front patchwork
★ gold silk scraps for halos
★ felt for Angel bodies
★ 8in (20cm) ribbon
★ polyester thread
★ glitter thread
★ needle
★ pins
★ scissors
★ beads or embroidery needle and thread (optional)
★ tracing paper
★ pencil
★ paper
★ iron
★ sewing machine

1 Trace the outlines of the stocking and band templates on p.38 and enlarge them on a photocopier. Fold the red corduroy, right sides together, and pin on the templates. Cut around them and mark on the seam allowance. Pin the band pieces onto the top of the legs and sew in place.

2 Reserve one half of the corduroy stocking for the back section. To create the patchwork background for the front section, cut out different shapes from a variety of scraps of fabric. Lay them on the stocking, with some overlaying others, until you are pleased with the arrangement.

3 Pin the scraps in place and sew them onto the corduroy with a close zigzag stitch on the sewing machine. Remove the pins, pressing the fabric as you go. Use a protective cloth between the iron and any delicate fabrics to avoid scorching and hot iron marks.

4 Cut out the Angel halo and body templates on p.38, and enlarge on a photocopier. Cut out three silk halos and three felt body pieces. Holding the two parts of each Angel together, arrange the Angels on the stocking. Pin the halos on first, then sew around the edges using a close zigzag stitch.

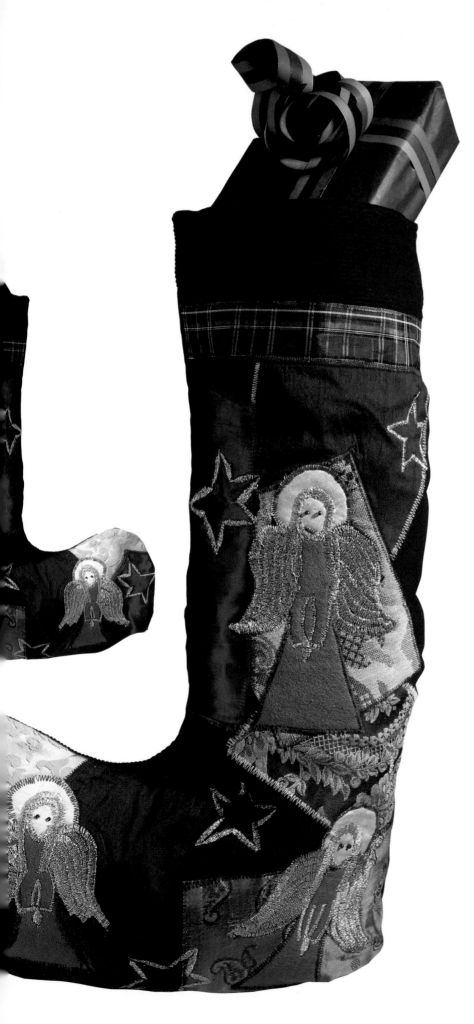

5 Pin the body pieces so they overlap the halos slightly and sew in the same way. Thread the sewing machine with glitter thread on the top bobbin and polyester thread in the smaller spool underneath the sewing foot. Sew lines of close zigzag stitches to fill in the wings and hair. Use lines of stitches for the hair.

6 Using a line stitch, sew star shapes onto the stocking between the Angels. Sew tiny beads onto the Angels' faces for their eyes, or use embroidery stitches if you prefer. Use a smaller width zigzag stitch to "draw" in the arms and hands.

★★★★★★★

*For neater stars with sharp points,
stop the line of stitches at the point
of each star, lift up the sewing foot
to turn the fabric, then replace
and continue.*

★★★★★★★

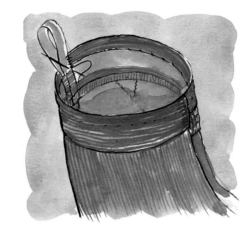

8 Turn over the top seam allowance,
rolling over a double hem on the
inside to hide any raw edges, and sew
close to the folded edge. To finish, snip
away any loose threads inside or
outside, and hand stitch a small loop of
ribbon to the top so the finished
stocking can be hung.

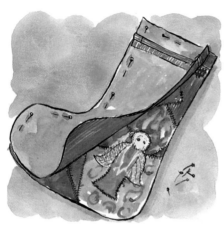

7 Place the two sides of the stocking
together, right sides facing, and sew
up the sides (including the bands)
using a straight stitch, leaving the top
of the stocking open. Snip the seam
allowance at the curves and turn right
sides out. Press carefully as before.

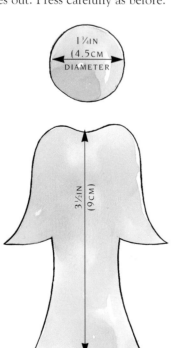

1¾IN
(4.5CM)
DIAMETER

3½IN (9CM)

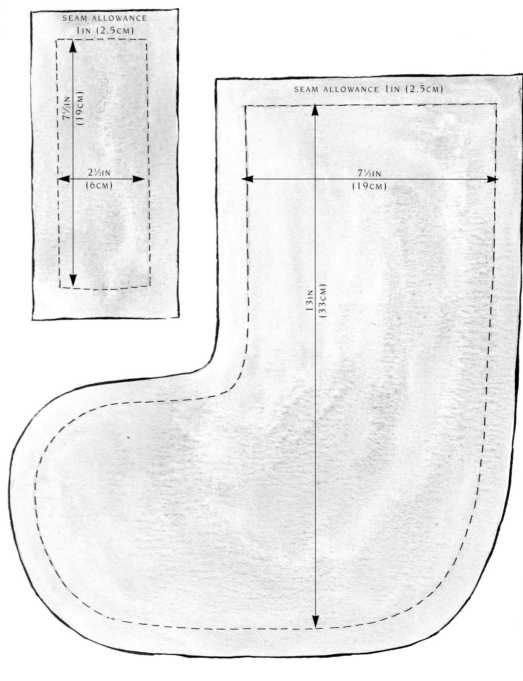

SEAM ALLOWANCE
1IN (2.5CM)

7½IN
(19CM)

2½IN
(6CM)

SEAM ALLOWANCE 1IN (2.5CM)

7½IN
(19CM)

13IN
(33CM)

BEADED LAVENDER BAG

This small organza bag is elaborately decorated with a printed fabric appliqué panel. The scented lavender will perfume clothes or linen when tucked inside a drawer or hung in your closet. However, the bags are so beautiful that it would be a pity to hide them away, and they look attractive simply tied on the bedpost or onto a chair back.

MATERIALS
★ *"Dylon Image Maker"* paste and brush
★ Angel image from greeting card or book
★ 12 × 12in (30 × 30cm) white cotton fabric
★ photocopier paper
★ sponge
★ 11 × 7in (28 × 18cm) silk fabric for the bag
★ 6 × 6in (15 × 15cm) colored silk or organza fabric
★ glitter thread
★ pins
★ darning needle
★ 20in (50cm) ribbon
★ small, gold beads (approx. 25)
★ 4oz (100g) lavender pot pourri
★ sewing thread
★ sewing machine
★ pinking shears
★ scissors
★ iron

1 Use a color photocopier to copy an Angel image onto paper to a size which is a bit smaller than the white cotton fabric. Apply a layer of *Dylon Image Maker* paste over the white cotton fabric. Press the photocopy firmly over this and smooth down with your hands. Allow to dry completely, then remove by wetting one end of the paper with a wet sponge and gently rolling it back with your fingers.

2 Cut the silk in half to make two equal rectangles. To prevent the edges fraying, sew a zigzag stitch close to the raw edges or, if you have one, use the overlock facility on your machine. Press the two pieces of fabric with an iron, reserving one silk rectangle for the back of the bag.

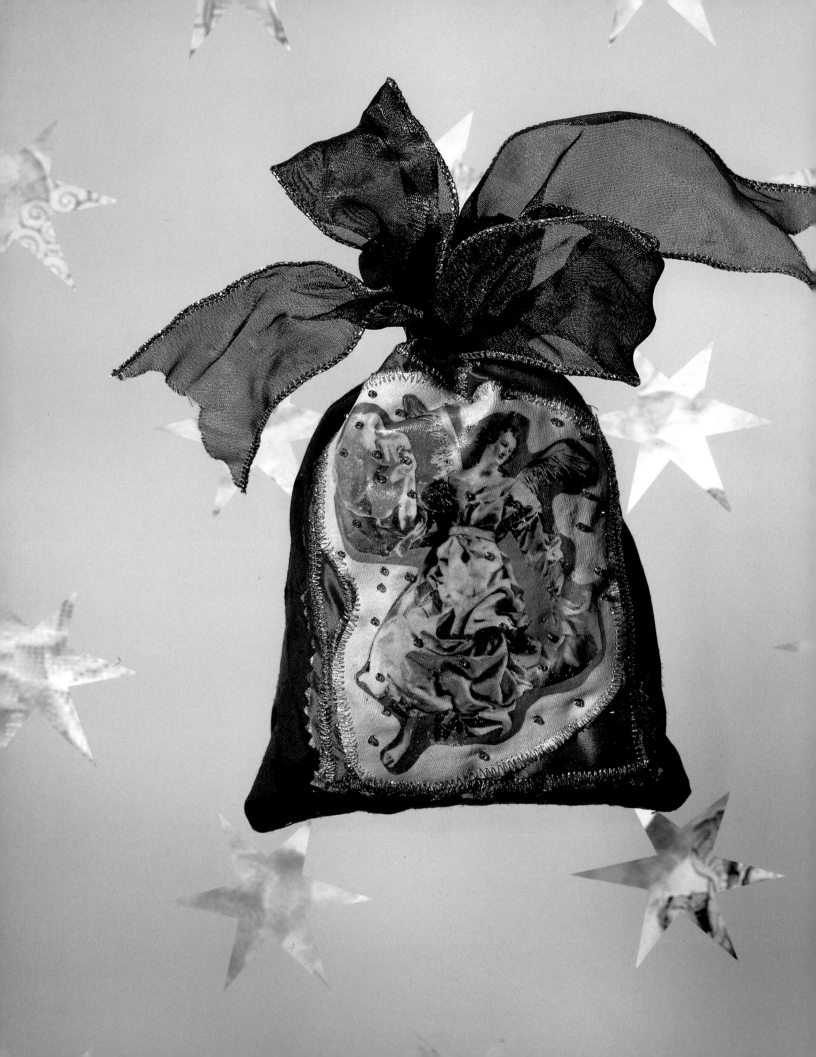

3 Cut the white cotton in an irregular shape around the printed image. Sew the shaped piece of printed fabric onto a rectangular, and "pinked", piece of silk or organza fabric using glitter thread for a pretty effect. Use a close zigzag stitch with glitter thread and trim this fabric, leaving a border of ¹/₂in (1.5cm) all round. Pin, then sew, this appliqué panel onto the front of the bag, remembering that the top 2in (5cm) of the bag will be folded over.

★ ★ ★ ★ ★ ★ ★

To use glitter thread without it breaking in the machine, always use a regular polyester thread in the bottom spool and the bobbin of glitter thread threaded onto the top of the machine.

★ ★ ★ ★ ★ ★ ★

4 Sew the front and back of the bag together around three sides, turn right sides out and press. Fold over 2in (5cm) at the top of the bag and use the machine to sew two lines of stitches inside this double band 1in (2cm) from the top fold, and only ¹/₄in (5cm) apart.

5 Thread a large darning needle with a 20in (50cm) length of ribbon and pass this through the stitched channel. The needle should pass through the fabric without any need for cutting. Thread the ribbon through, then out again using the same hole.

6 Decorate the appliqué panel using the beads. Fill the pouch with scented lavender and tie the ribbon to secure the pot pourri inside.

If I have freedom in my love,

And in my soul am free,

Angels alone that soar above

Enjoy such liberty.

Richard Lovelace

TRINKET BOX

Five color photocopies are used to decorate the five faces of this box. Gold metallic paint markers are readily available from good stationery shops and are invaluable for this type of decoration as their ink flow is perfectly smooth and continuous. Always check the copyright details in books or on cards when looking for an image to reproduce under the photocopier.

MATERIALS
★ wooden box
★ Angel image color photocopies
★ latex paint to cover box
★ fine sandpaper
★ all-purpose glue
★ ruler, pencil and tool compass
★ gold metallic paint marker
★ spray adhesive
★ polyurethane varnish

1 Color photocopy your chosen Angel image. You may need to use the enlargment or reduction facility on the copier, depending on the size of the box you are decorating.

2 Paint the wooden trinket box with at least two coats of colored latex paint for a good, even coverage. If the box has a slightly rough surface, you may need to sand between coats using a fine grade paper. Cut Angels from the copies, choose their positions on the sides of the box, then glue them on.

3 With the straight edge of a ruler, work out the pattern on the sides and lid of the box. A tool compass will be needed to outline the four circles on the lid. Outline using a soft pencil, then fill in using the gold marker. Almost every trinket box will be different, so use our decoration as an approximate guide for your own.

Music is well said to be the speech of angels.

Thomas Carlyle

4 Seal the printed surface of the color copies with a spray adhesive. This will prevent the printed inks from bleeding once the varnish is applied. Protect the box using at least three layers of polyurethane varnish, allowing each coat to dry thoroughly before applying the next.

5 To line your box measure the four sides and add 1in (2.5cm). Measure the depth of your box and add 4in (10cm). Use these two measurements to cut out a piece of red satin. Cut the fabric into four equal triangles. Using a sewing machine sew the raw edges underneath and glue the fabric, right side out, with the bases of the triangular pieces positioned at the top box edges. Glue as close to the inside edges of the box as possible. Remember to make sure your lid will still fit before you glue down the lining fabric. Glue the points of the triangular pieces where they meet in the center of the base of your box.

★★★★★★★

As each copy is printed, place it next to the original under the copier to create multiple images. In this way you keep the photocopy expenses to a minimum.

★★★★★★★

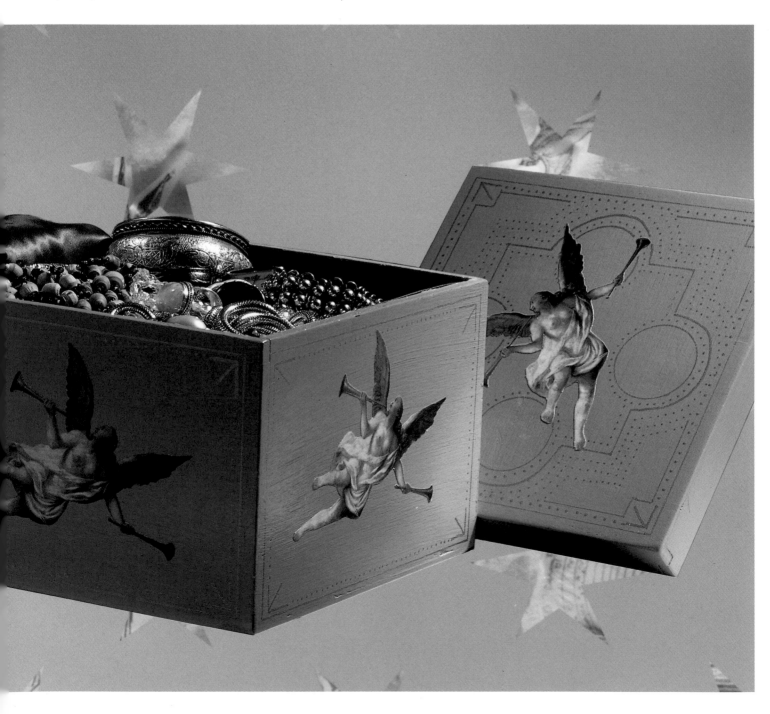

PAINTED GLASS

Durable glass paints are simple to use and dry to a hardwearing finish. Here, only gold paint is used, but other colors are easily mixed, so you need only buy the basic palette — pinks, grays, and browns can all be mixed from these. The image looks impressive, but it is easy to achieve. The traced image is taped to the inside of the glass and used as a guide for painting.

MATERIALS
★ wine glass
★ glass cloth
★ tracing paper
★ pencil
★ scissors
★ adhesive tape
★ glass paints
★ dish or mixing palette
★ very fine artist's brushes
★ denatured alcohol
★ rags or cotton swabs

1 Wash the glass in hot soapy water to remove any trace of grease. Dry well, using a glass cloth, and try to handle the glass itself as little as possible from now on. Hold the stem with the glass cloth as you start to paint, as the smallest trace of grease on your hands will spoil the finished design.

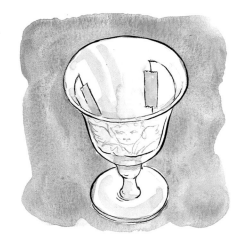

2 Trace around the outline on p.45 and cut away the excess paper. Tape the tracing to the inside of the glass. Make sure it lies as flat as possible – glasses have a curved surface, so the tracing will not lie perfectly flat, but the closer it is to the glass, the easier it will be to copy the outline.

3 Pour a small amount of gold glass paint into the dish to mix it to an even consistency. Use a fine brush, thinning the color with a little denatured alcohol if necessary. Follow the trace outline as closely as you can, and keep a rag or a cotton swab ready to wipe away any mistakes. Rest your arm on the edge of your work surface and cradle the glass in your other hand to keep the brush steady. Wash your brush in denatured alcohol.

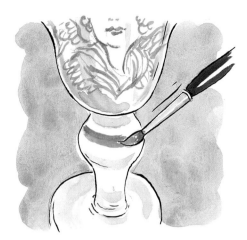

4 Finish the glass by painting a strong color around the stem or use gold paint again for a subtle, stylish effect. Wait for the image on the bowl of the glass to dry to avoid possible smudging. To add a little "body" to the paint, mix a little white paint with the transparent color. Leave the glass to dry completely before you use it. It should be washed by hand rather than in a dishwasher and patted dry after washing – not rubbed.

TEMPLATE SHOWN HERE AT 90%

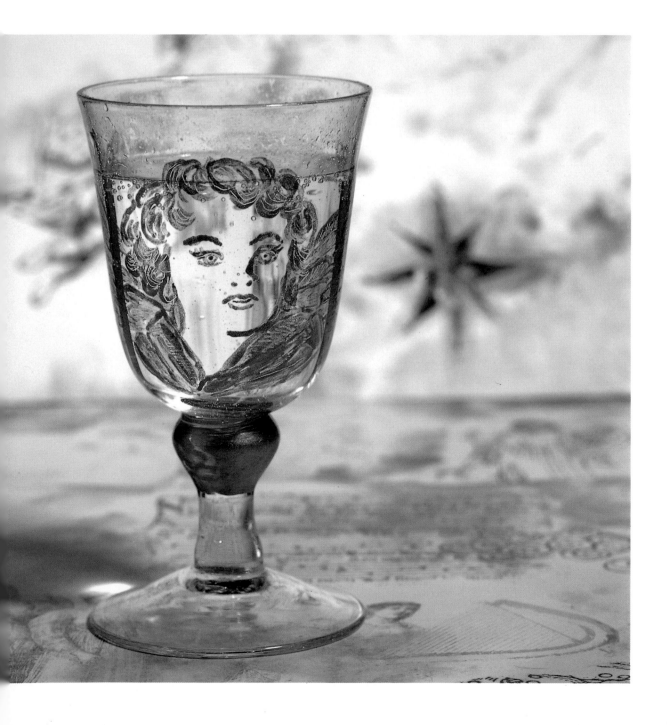

DECORATIVE PILLOW

Just like the "Beaded Lavender Bag" this technique lets you transfer a printed paper copy directly onto fabric, which can then be sewn and washed just like any other printed fabric. Warning: Always be aware of the copyright law that protects original works. You can copy most images, provided the project being made is for your own use, rather than for retail sale.

MATERIALS

★ 13 × 13in (33 × 33cm) pillow pad
★ 32 × 16in (80 × 40cm) silk fabric (gold)
★ Angel image color photocopy
★ *"Dylon Image Maker"* kit
★ 10 × 10in (25 × 25cm) white cotton fabric
★ twisted cord 55in (140cm)
★ newspaper
★ scissors
★ sponge
★ sewing machine
★ iron
★ thread
★ needle

1 Transfer your printed photocopy onto the backing fabric, carefully following the manufacturer's instructions. Once you have left the image to dry for the required time, roll the paper away from the back of the photocopy using water and a sponge. Dry the printed fabric and cut to size. You will need a perfect square, 10 × 10in (25 × 25cm), to fit neatly inside the front of the pillow case (see Step 2).

2 Cut two 14 × 14in (35 × 35cm) squares of gold fabric, on the reverse side mark on ½in (1.5cm) seam allowance all around both squares. Keep one square for the back.

3 To make the front, mark an inner square 2in (5cm) inside the seam allowance on the reverse side of the fabric. You can either pin this square and use it as a positional guide when you place the printed image on the front section, or cut the square out and place the printed fabric in the gap – but in this case remember to leave 2½in (6cm) material from the seam allowance as this will allow enough material to sew on the printed fabric.

4 Pin then sew the printed fabric in position using a running stitch on the sewing machine following a line as close to the edge of the printed fabric as possible.

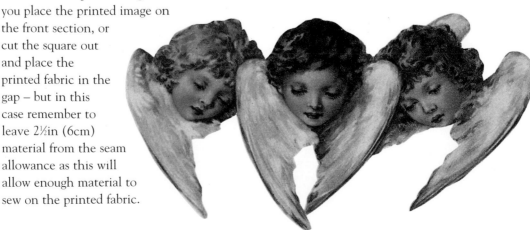

5 Put the back and front sections right sides together and sew along the seam allowance using a running stitch. Leave a gap open on one side for turning and stuffing. Turn the case through to the right side and stuff with the pillow pad. Hand sew the gap closed and decorate the edge of the pillow with a length of twisted cord. Use discreet hand stitches for these finishing touches.

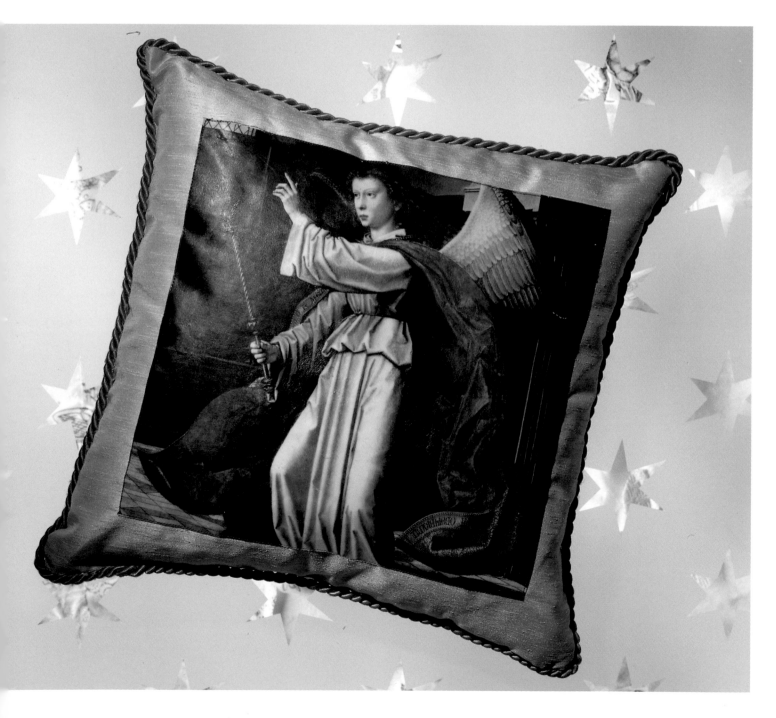

HATBOXES

These attractive hatboxes will not only look good in a bedroom, they provide useful storage space for many things besides hats. Make a single box or build a tower of them. Use a photocopier to produce as many Angel motifs as you require.

MATERIALS
★ Angel image photocopies
★ hatboxes
★ white latex paint
★ brushes
★ colored inks
★ all-purpose glue
★ spray adhesive
★ crackelure varnish – oil-based antiquing varnish and water-based crackle varnish
★ scissors
★ burnt umber oil paint

1 Photocopy the Angel images on p.50, or see *Découpage Inspirations* on pp. 122-5. The size of your box determines the number of copies but, as black and white copying is inexpensive, it is always a good idea to run off more copies than you think you will need. Remember to include an extra one for the lid. Fix the printing ink with a layer of spray adhesive (see *photocopy section* on p.20). Cut the Angels from the page using sharp scissors.

2 Paint the outside of the hatbox and its lid with white latex paint. Use two coats, if necessary, to create a good flat finish. Allow the paint to dry. Tip a little colored ink into a container, and dilute with the same amount of water. We used a different color for each hatbox – one yellow, one green.

3 Thin the glue with a little clean, cool water until it is the consistency of light cream. Brush this over the area of the hatbox where the first photocopy will be stuck down. Place the cut-out photocopy over the glue, fixing the center down first and pressing the edges down as you work outwards to avoid air bubbles (see *découpage section* on pp.21-3).

4 Repeat until the hatbox is covered and the Angels are equally spaced around the box. Use the thinned inks to paint around the box lid. Scrub a little brown ink into the yellow ink while this is still wet to add definition. Likewise add a little blue ink to the green ink, building up a patchy effect. Work the colors over the photocopies, adding stronger tones of the main color to accentuate the clothing.

*Every visible thing in
this world is put in the
charge of an angel.*

Saint Augustine

263 4326

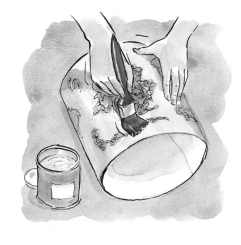

5 When the hatbox is totally dry, brush on a thin layer of the crackelure varnish. The first layer is the oil-based antiquing varnish. When this has almost dried, but is still slightly tacky to the touch, apply a thin layer of the water-based crackle varnish. Because the two varnishes have different drying rates they form a crazed, crackle effect on the surface. Once this is dry, the cracks can be highlighted by rubbing a little burnt umber oil paint into the surface of the varnish using a cotton rag. Leave to dry.

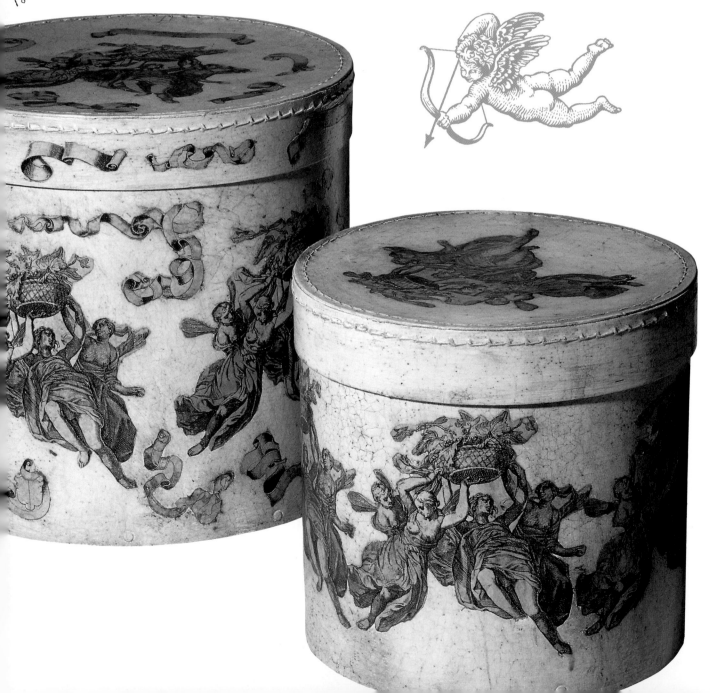

ALL TEMPLATES PRINTED AT HALF-SIZE

hinc et hinc labellis errantes animas. Valete, curae mortaless. Pulchra comis annisque decens et candida vultu dulce quiescenti basia blanda dabas. Si te iam vigilans non unquam cernere possum, somne precor, iugiter, lumina nostra tene.

LAMPSHADE

Personalize an old or new lampshade using this effective technique. The only other materials you will need are a fine fiber-tipped marker and, surprisingly, a cold cup of tea — not for drinking but for painting with, so do not add creamer! The cold tea dries to a parchment-like finish that actually mellows the light. Once the tea is dry, the photocopied Angel image is held at the back of the shade and the light is switched on. The light projects the black and white outline through the fabric covering, leaving you with a perfect outline to trace around. It couldn't be simpler.

MATERIALS
- ★ lampshade
- ★ chalk
- ★ tea bags
- ★ decorator's brush
- ★ Angel photocopy
- ★ Latin script photocopy
- ★ scotch tape or removable adhesive mounting pads (Blutack)
- ★ fine fiber-tipped marker (black)

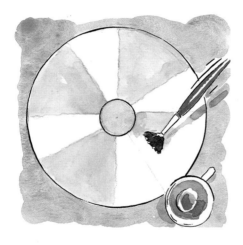

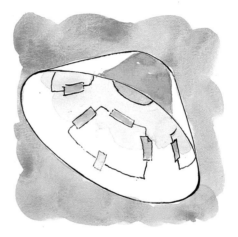

1 Remove the shade from its base and place it in front of you so you look directly down at the hole at the top of the shade. Starting at the seam, mark the points along the top in the 12, 2, 3, 5, 6, 8, 9, 11 o'clock positions. Turn the shade upside down and repeat along the bottom edge. Join the corresponding positions together using a very light chalk mark.

2 Steep two tea bags in a small cup of boiling water and leave to go cold. Use the decorator's brush to apply a thin wash of tea to the shade. Using the chalk marks as your guide, paint in four bands of tea stain between the 12 and 2 o'clock positions, the 3 and 5 o'clock, the 6 and 8 o'clock and the 9 and 11 o'clock positions.

3 Photocopy the outline of the Angel and a selection of Latin script on p.53, or choose your own images. The script we used was from an old journal, but you could use any script or copperplate – often found on copies of old deeds and legal documents. When the tea stain is dry, fix the copies underneath the shade using small pieces of tape or adhesive mounting pads.

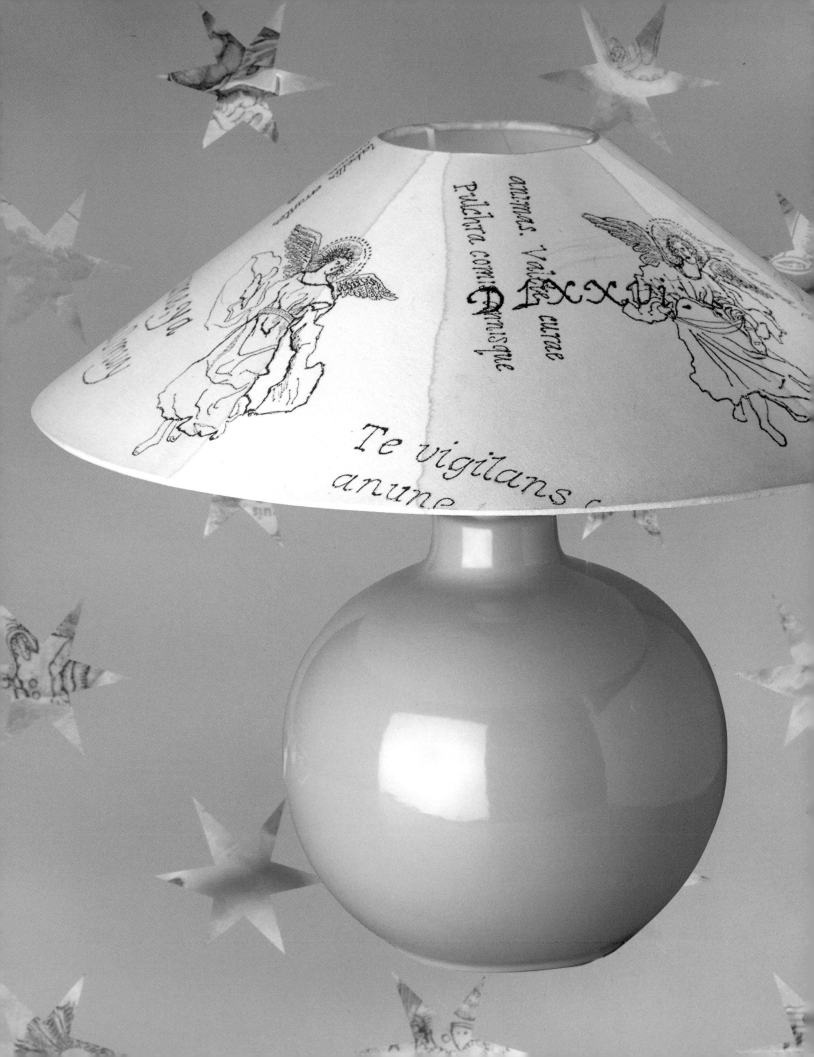

4 Fix the shade onto the lamp base and turn the light on. The Angel outline will be projected onto the surface of the shade. Use the fine fiber-tipped marker to trace around these outlines, marking the Angel directly onto the shade. Use a fine scratchy line to denote details such as the features, face and wings, and a slightly thicker line for the clothing and feet.

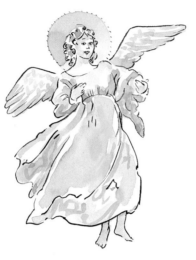

TEMPLATE USED AT 5IN (12CM) HIGH
4IN (10CM) WIDE

5 Repeat this procedure to draw all four Angels around the shade, ensuring that they are evenly spaced. Use the same technique to project the lines of photocopied text, writing directly onto the shade using the same fine marker. It is effective if you use large and small font script. Remove the photocopies when finished. Never leave the lamp switched on for long with the photocopies still in place, as this could be a fire risk.

Te vigilans oculis, animo te nocte requiro, victa iacent solo cum mea membra toro. Vidi ego me tecum falsa sub imagine somni. Somnia tu vinces,

PAPER ANGEL CUT-OUT

This delightful framed cut-out is perfect as a special gift for someone you love, perhaps on Valentine's day or as a keepsake gift for a new baby. The symmetrical heart shape is hung away from the back of the frame by thread, with a small Angel also "floating" inside the heart.

1 Enlarge the template outline on p.56 on a photocopier until it is an appropriate size for your frame. Use the photocopy to make a tracing. You will only be needing half of the heart at this stage.

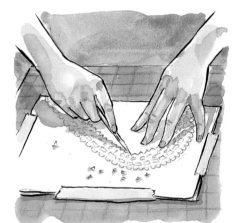

MATERIALS
★ tracing paper
★ pencil
★ drawing paper
★ masking tape or scotch tape
★ paperclips
★ craft knife or scalpel
★ cutting mat
★ sewing needle and cotton thread
★ scissors
★ display box
★ colored paper or thin colored card for the frame's background

2 Fold a piece of drawing paper in half and secure the edges of the paper firmly with strips of masking tape or scotch tape, to ensure the cut-out does not shift during cutting. Place the tracing paper on the fold, making sure that the right side, with the pencil markings, is face down onto the drawing paper. Secure the tracing paper with paperclips.

3 Draw around the outlines using a sharp pencil. Remove the tracing and, on a cutting mat, cut out the design using a sharp blade – you may find a scalpel blade works best of all. Cut from the center of the design outwards. Work slowly, taking care not to cut across any bridges that should be left in place. When the cutting is finished, open up the heart very carefully and press it between the pages of a book to flatten it out.

4 Place the trace of the Angel template on the fold of a double thickness of drawing paper. Cut the Angel out as in Step 3. Put thread through the top of the Angel's head and hang it from the cleft of the heart shape. Knot the thread neatly at the back of the cut-out.

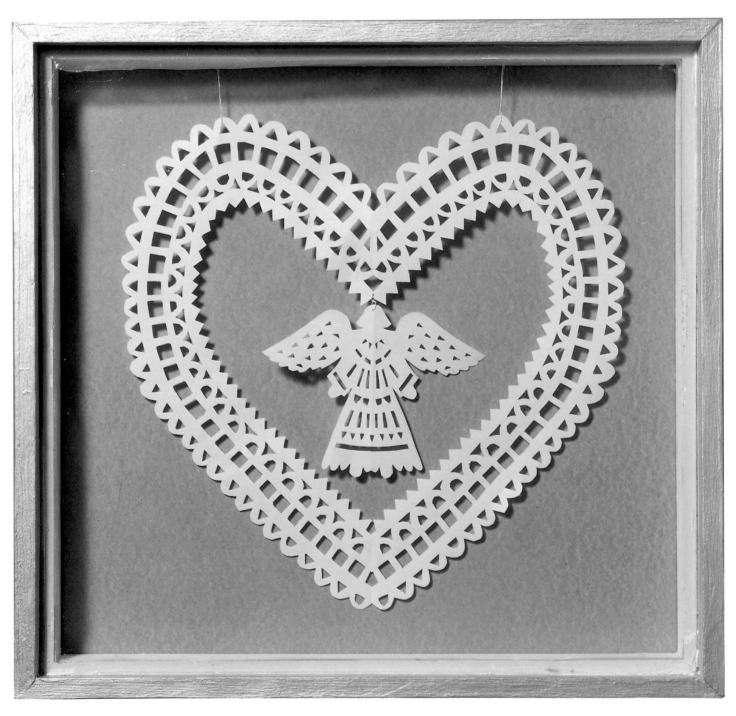

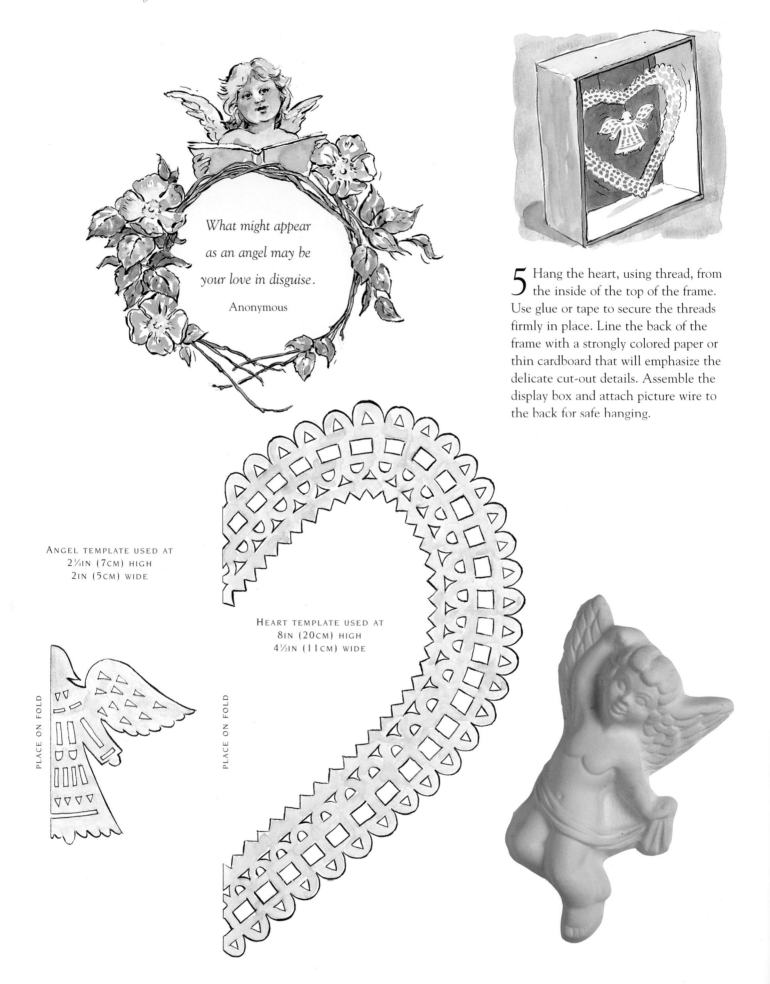

*What might appear
as an angel may be
your love in disguise.*

Anonymous

5 Hang the heart, using thread, from the inside of the top of the frame. Use glue or tape to secure the threads firmly in place. Line the back of the frame with a strongly colored paper or thin cardboard that will emphasize the delicate cut-out details. Assemble the display box and attach picture wire to the back for safe hanging.

ANGEL TEMPLATE USED AT
2¾IN (7CM) HIGH
2IN (5CM) WIDE

HEART TEMPLATE USED AT
8IN (20CM) HIGH
4½IN (11CM) WIDE

PLACE ON FOLD

PLACE ON FOLD

CHRISTMAS ANGEL WREATH

This beautiful hanging wreath can be decorated with seasonal holly or ivy leaves. When the holiday season is over, remove the leaves and pack the wreath away, ready to be brought out the following year and decorated once more.

The wreath can be as simple or as sophisticated as you wish. In addition to the evergreen leaves, it could be decorated with bundles of wired cinnamon sticks, whole nutmegs, dried fruit rings or bunches of herbs.

MATERIALS
★ twig wreath base – most good florist shops stock these before the holiday season
★ tracing paper
★ pencil
★ pins
★ 8 x 8in (20 x 20 cm) plain cotton
★ scissors
★ sewing machine
★ 1oz (25g) polyester stuffing
★ needle & thread
★ all-purpose glue
★ tempera paints
★ gold acrylic paint
★ fine fiber-tipped marker
★ fishing line
★ ribbons – length depends on the size of the wreath
★ ivy, holly leaves or decorations of your choice

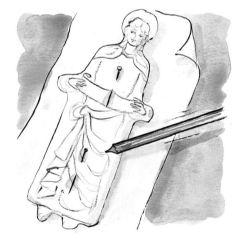

1 Use the template on p.59 to make a tracing of the Angel. Cut around the outline and mark on a seam allowance, approximately ¼in (0.5cm), all round. Pin the tracing onto a double thickness of thick, plain cotton and cut around the outline, including the small seam allowance.

2 Pin the two pieces together and sew around the seam allowance using a straight stitch on the sewing machine. Leave a small gap along a straight edge, for turning – the lower part of the wings, for example. When the Angel is turned out, stuff it lightly, then sew the gap closed using tiny hand stitches.

3 Retrace the reverse side of the Angel tracing with a soft pencil and place it, right side up, onto the stuffed calico shape. Pin the tracing onto the calico to prevent it moving and trace down the outline onto the surface of the shape. The pencil lines will be faint, so once the tracing is removed these lines can be thickened up a little with the pencil.

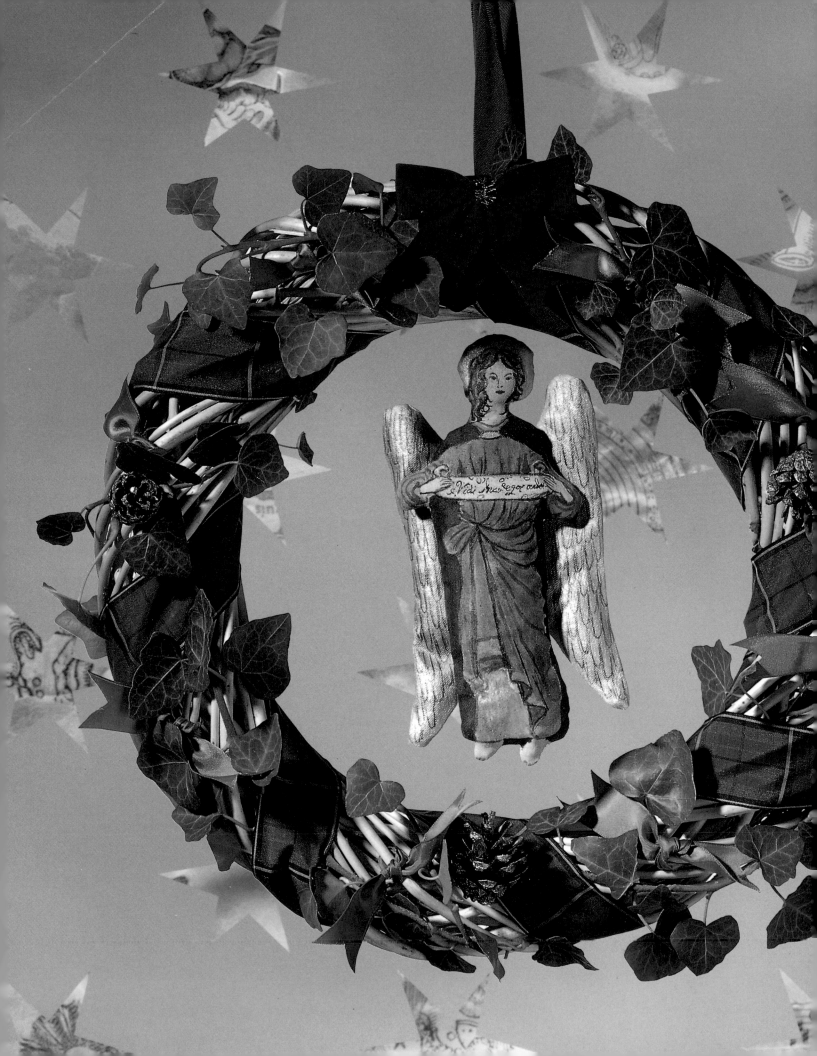

5 Start to paint in the Angel, referring to the tracing as you are working. Paint in the lightest colors first, including the skin tones. Apply the paint for the dress using long strokes of color. Paint the feathers and halo using the gold acrylic paint. When the main part of the Angel has been painted you may prefer to draw in the features and pick up details within the hand-held scroll using a fine fiber-tipped marker.

4 Paint a fine layer of white craft glue over the top surface and allow to dry. This will dry to a stiff finish which will be easier to paint on. The pencil lines should still remain visible underneath the glued surface but, if some have become too faint, then mark these in again with the pencil.

6 When all the paint has dried, seal and protect the surface with another thin layer of white craft glue. Thread a loop of cotton thread or fishing line onto a needle and pass this through the top of the Angel's halo, to hang it onto the twig wreath. Make sure the Angel hangs exactly in the center once the wreath is hung up.

7 Decorate the wreath with long twists of satin ribbon, adding small ribbon bows around the edge. Wind long stems of trailing ivy around and around the wreath. Include more decorative touches to your wreath as required and hang it up to be admired.

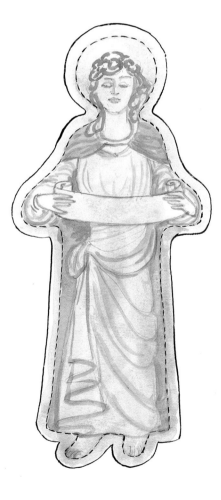

TEMPLATES SHOWN HERE AT 60%

ANGEL COMFORTER COVER

Ten stenciled panels are sewn together to make the front section of this lovely comforter quilt cover. It's easy to make your own stencils and the materials are inexpensive. Fabric paints are essential — do not try to use regular stencil paints as these will simply wash away when you clean the cover. The fabric colors are easy to use and fix onto the fabric using a hot iron. We have used a natural cotton muslin for the comforter quilt cover as this is inexpensive and easy to wash. Check that the fabric you are using is pre-shrunk, the color is fast (if applicable), and the fabric can be easily cleaned.

MATERIALS

★ tape measure
★ repositioning spray adhesive /double sided tape
★ manila board / or stenciling acetate sheet (see Stenciling section, pp. 30-31)
★ craft knife
★ cutting mat, or cork or linoleum floor tile
★ fabric
★ scissors
★ grippers
★ fabric colors
★ pliers
★ stencil brushes
★ scrap paper
★ cotton cloth (to protect the fabric colors when during pressing)
★ iron
★ sewing machine
★ thread

1 Photocopy the templates on p.62 and enlarge the main Angel image until it will fit neatly inside the 18 × 12in (45 × 30cm) panels of the cover.

2 Spray a light film of repositioning spray over the back of the photocopy and smooth the copy over the manila board or acetate film. Cut around the solid areas of the motif using a sharp craft knife. Work on a cutting mat or a soft cutting surface such as a cork or linoleum floor tile.

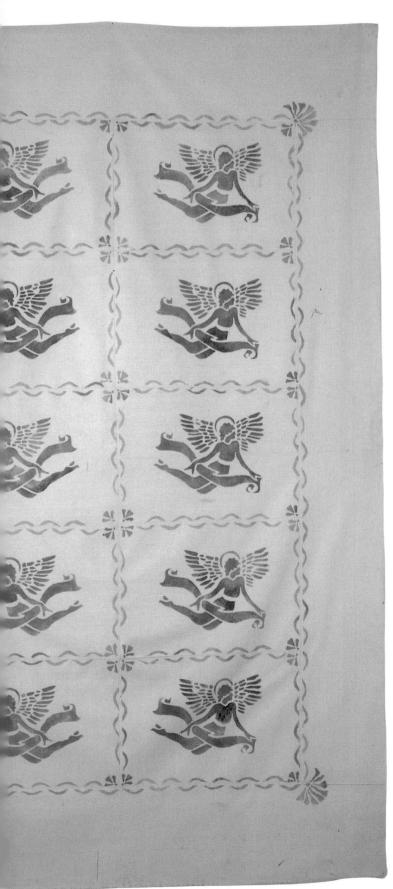

3 Cut the fabric rectangles to size. You will need ten rectangles, each measuring 18 × 12in (45 × 30cm) with an additional ¹/₂in (1cm) all round for a seam allowance.

4 Spray the back of the cut stencil lightly with repositioning spray. Place a thick wad of newspaper underneath one of the fabric panels and position the cut stencil over the fabric.

5 Tip a little of the first fabric color out of its pot onto an old dish. Dip the stencil brush into the color and dab off the excess paint onto a piece of scrap paper. Stipple the color through the stencil using a tapping movement with the brush. Hold the brush vertically at all times so the paint does not seep under the cut edges. If you are using several colors, blend them evenly by overlapping them while they are still wet.

Hush! my dear,
lie still and slumber,
Holy angels guard
thy bed!

Isaac Watts
DIVINE SONGS

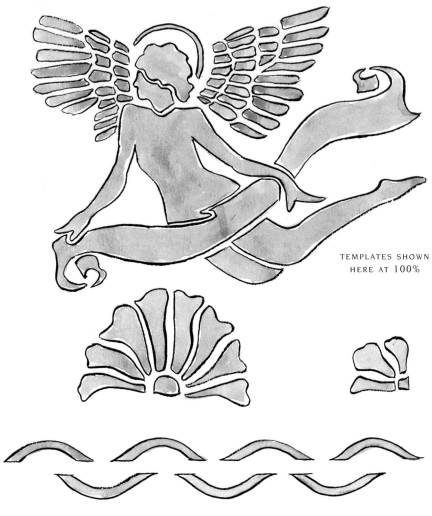

TEMPLATES SHOWN
HERE AT 100%

6 Remove the stencil and repeat the image on all nine remaining panels. When the fabric paint has dried, cover the surface of the paint with a protective cotton cloth (an old dish towel is perfect) and press with a hot iron to set the colors.

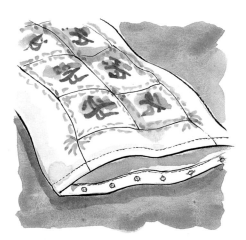

7 Using a sewing machine, sew two stenciled panels together on one edge only to make a pair. Sew the remaining eight panels into pairs – making sure that all the Angels are facing in the same direction. Stitch the pairs together so that you have a block for the front section of your comforter cover made of five panels deep by two panels wide. Press all the seams open.

8 Cut two strips of muslin 74 × 10in (188 × 25cm) and two strips 56 × 10in (142 × 25cm). Sew these strips onto the sides of the panel block to make the border. Press the seams open at the back. Lay the cover right side up onto a flat surface and paint on the border stencils along the seams of panels and and the borders. Add the flower motif at the corners where panels meet.

9 Cut out a 96 × 58in (244 × 147cm) piece of muslin for the back of the cover. Lay it over the front cover, right sides together, and pin, then sew along three sides of the cover. Keep one short side open. Turn over a double hem on this opening of the cover. Attach grippers or snaps as a neat fastening for the opening of the cover. Turn the cover right side out and press.

LACE ANGEL

These lacy Angels are so simple and quick to make that you could find yourself with enough to decorate an entire Christmas tree in a suprisingly short time. Ribbons, lace doilies and tiny styrofoam balls are all you need — no drawing, painting, or embroidery required. As an alternative to solid white, you could pre-dye the lace and ribbons to match a particular color scheme you have planned for the holiday decoration.

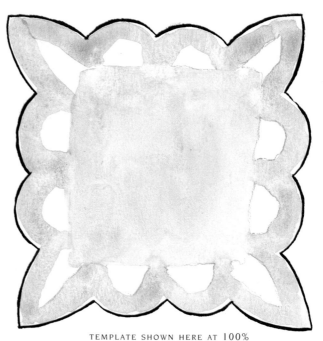

TEMPLATE SHOWN HERE AT 100%

MATERIALS
★ 3in (7.5cm) square fabric lace doily
★ 2in (5cm) square fabric lace doily
★ 4in (10cm) round cluny doily
★ 79in (2m) of ⅛in (3mm) white satin ribbon
★ 24in (60cm) of ¹⁄₁₆in (2mm) gold "bendable" ribbon
★ ¾in (18mm) styrofoam ball
★ chenille needle
★ thin knitting needle
★ low temperature glue

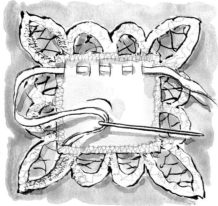

1 Cut the ribbon into 11in (27cm) lengths. Thread one piece of ribbon through the chenille needle. Hand sew a ¼in (6mm) running stitch through the fabric next to the lace of a 3in (7.5cm) square doily. Pulling the ribbon through the fabric is difficult; it will help to take only one or two stitches at a time. A rubber disk (sold in notions departments) can make this job easier.

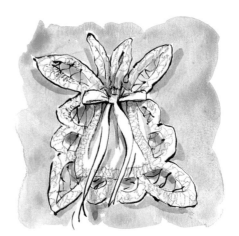

2 Tighten the ribbon as firmly as possible and tie a square knot at the center front of the doily. This forms the body. Tie a bow on top of the knot. Fluff the top lace edge to create a stand-up collar for the Angel's head.

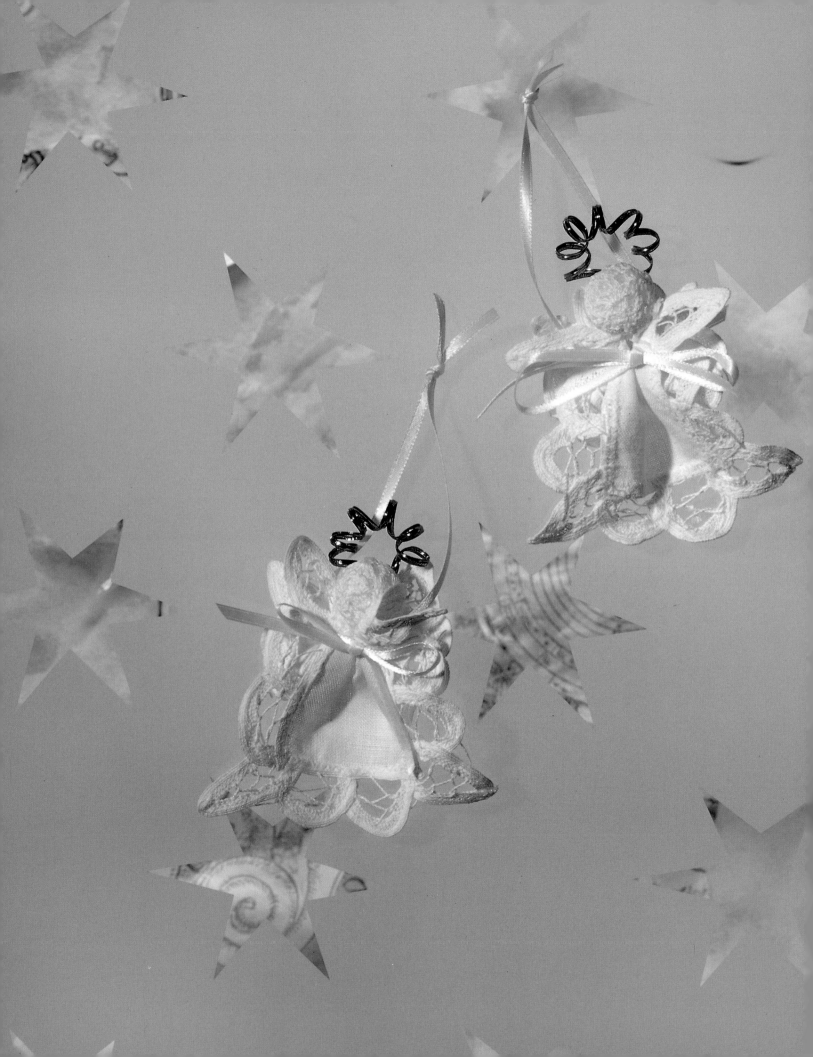

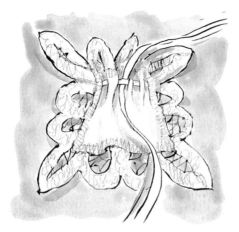

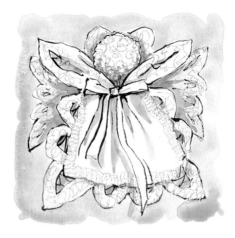

3 Using another length of ribbon, make one vertical ¼in (6mm) stitch on the gathered ribbon line on the back of the doily body. Leave at least 4in (10cm) of ribbon hanging from the bottom stitch.

6 Place the covered ball, with the raw edges down, into the neck of the gathered body. Glue in place.

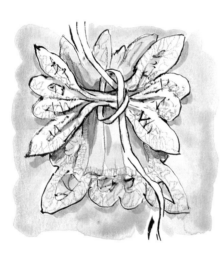

4 Crease the center of a 2in (5cm) square doily as a guideline. Pinch along the center line to form the wings. Lay the gathered doily on top of the ribbon and tie a square knot to secure the wings to the body. Tie a bow on top of the knot.

5 Cut a cluny doily in half. Center the styrofoam ball on one half. Wrap the doily to cover the ball. Glue the edges of the doily to the ball. Trim away the excess lace.

7 Wrap 3in (7.5cm) of gold "bendable" ribbon around a thin knitting needle, leaving ½in (12mm) on each end of the ribbon straight. Slip the knitting needle out from the spiraled ribbon. Bend the ribbon into a circle and twist the ends together.

8 Pierce the doily and ball at the back of the Angel's head, deep enough to create a hole for the ribbon ends to be inserted to form the halo. Glue the ends into the hole.

9 A hanger can be made from the remaining ribbon. Loop the ribbon under the wings. Bring the ribbon ends above the Angel's head and tie them together in a knot.

ANGEL DOLL

This pretty Angel doll

would make a special gift for a child. She is made from a combination of richly textured fabrics including satin, organza and silk, and her exquisite accessories include a beaded necklace and brocade waistband.

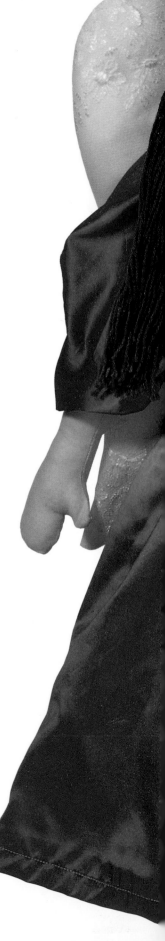

MATERIALS
★ tracing paper
★ pencil
★ 10 × 12in (25 × 30cm) solid white, thick cotton fabric Also, 10 × 12in (25 × 30cm) patterned or colored thick cotton fabric
★ 22 × 16 in (56 40cm) silk fabric for dress
★ 11 × 8in (28 × 20cm) white silk or lace for wings
★ scissors
★ needle & thread
★ 2oz (50g) polyester stuffing
★ fine fiber-tipped markers
★ fine artist's brush for fabric paints
★ fabric paints: red, white, blue, black
★ white craft glue
★ red wool
★ thin paper
★ sewing machine
★ gold acrylic paint
★ ribbon

1 Enlarge the templates on p.68 to make the pattern pieces needed for the doll. You can draw facial features onto the tracing paper at this stage as they will be needed to transfer onto the face once the doll is made up. Trace the outline and seam allowance markings onto tracing paper.

2 Cut a 10 × 4in (25 × 10cm) piece of the plain fabric and sew it onto a 10 × 7in (25 × 18cm) piece of colored fabric across the 10in (25cm) edge. Press the seam towards the colored fabric on the reverse side. Fold this fabric in half across the width, right sides together, keeping the raw edges together and seams matching. Place the body pattern onto the doubled fabric, aligning the seam line on the fabric with the bodice line marked on the tracing. Pin the pattern in place and cut out the two body shapes for the front and back of the doll.

3 Sew around the body seam, leaving a small gap at the side for turning. Clip the curved seams through the seam allowance, close to the line of stitches to ease the turning. Turn through to the right side and stuff firmly, particularly in the neck area. Sew the gap closed with tiny hand stitches.

4 Use the arm pattern to cut out four arm shapes from the plain fabric. Put two matching arm pieces together and sew around the seam, leaving a small gap open along the side. Clip the curved seams and trim the seam allowance close to the line of stitches around the thumb area. Turn the arm through to the right side. Stuff firmly as before and sew the gap closed. Repeat for the other arm.

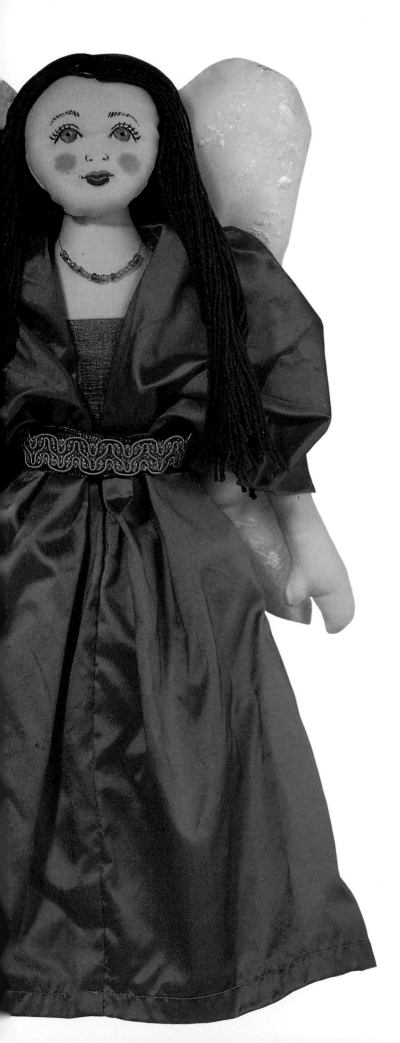

5 Pin the leg pattern onto the plain fabric and cut out four leg pieces. Repeat the same steps as used for the arms. Cut the seam allowance around any curves to ease turning. Stuff the legs firmly and close the gap.

6 Place the head pattern onto the plain fabric and cut out two fabric pieces. As before, sew around the seam allowance, leaving a small gap for turning. Turn through, but do not stuff yet. Place the traced head pattern piece onto the face and trace off the facial features. Lift off the tracing to reveal the faint outlines of the doll's eyes, nose and mouth.

7 Carefully draw in the eyes, nose and mouth, using a fine marker. Take care to use a waterproof marker if the doll is likely to be washed. Draw the eyebrows in using fine strokes rather than one continuous line. Paint in the iris using a little blue fabric paint adding a little white into the blue in the "half past to quarter to" section of the iris.

TEMPLATES SHOWN HERE AT 80%

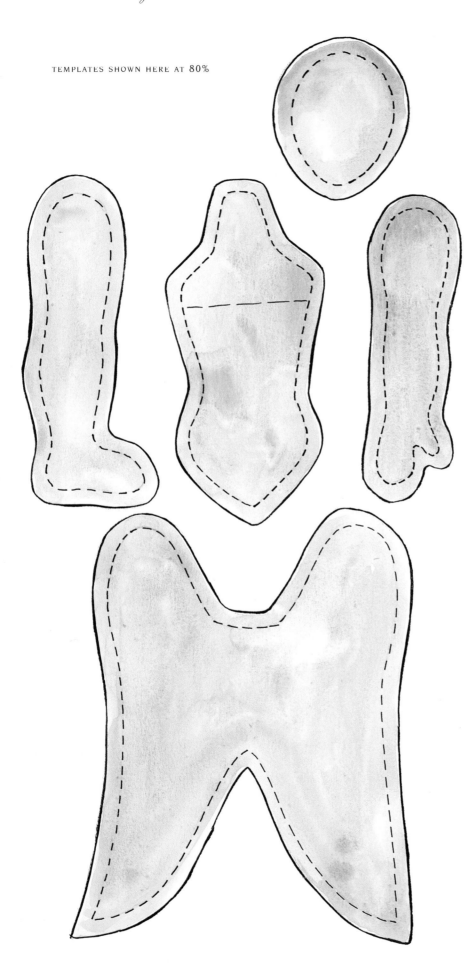

8 Paint the mouth red, adding a little highlight of white along the upper part of the lower lip. Paint the pupil black and add a small dot of white paint on the top right hand quarter of each eye. Touch up the corners of each eye with a little white paint. When the features are quite dry, seal the surface of the painted details with a little white craft glue. This is milky white when wet, but it will dry clear.

9 Stuff the head and sew the gap closed as before. Thread a needle with strong thread and, starting at the back of the head, push the needle upwards to the corner of one eye, take a small stitch, then pass the needle back through the head to its starting position and pull the stitch gently. Secure with three small stitches at the back of the head. Repeat this small stitch to the other eye to create a soft sculptured feature to the face.

10 Sew the legs onto the body using strong thread, and stitch on the arms. Cut through the fabric on the back of the head and remove a little stuffing. Push the neck into the gap and position the head as desired. Make a narrow turning on the cut edges. Pin, then stitch closed for a firm attachment.

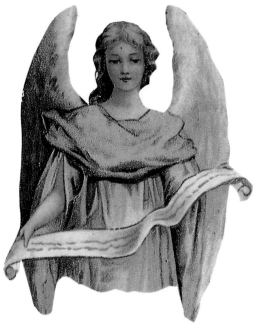

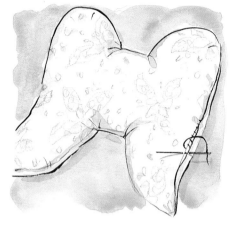

12 To make the doll's dress cut two pieces of silk material measuring 22 x 8in (57 x 20cm) each. Turn under a small hem along the two long sides of each piece.

Pin the two pieces, right sides together, and stitch along one long side leaving a gap of 12in (30cm) in the center for the neckline. Turn out and press. Fold the material in half lengthways, right sides together, and sew up the side seams from the bottom of the dress leaving a 3in (7.5cm) gap at the top of each side, where the material is folded, as gaps for the arm holes. Turn out and fit over your doll.

13 Paint the shoes of the doll gold using the acrylic paint, and thread small beads onto strong thread to fasten around her neck for the delicate necklace. Cover the stitches at her waist with a length of ribbon.

14 Place the pattern for the Angel wings onto a double thickness of white silk or lace fabric, keeping the right sides together. Cut out the two pieces. Pin, then sew, around the seam allowance as for the other pattern pieces. Leave a small gap for turning through, then stuff lightly and sew the gap closed.

15 Sew the Angel wings onto the back of the doll, aligning the center of the wings with the center of the back. Pin the wings in place, check their positioning, and backstitch in place, making sure they are firmly attached to the doll.

11 Cut enough 16in (41cm) lengths of red wool to make a neat bundle that is 3in (7.5cm) wide at the center. Lay the strands across the piece of thin paper and machine stitch the hair strands together through the center. Discard the thin paper once the strands of hair are secure. Pin the hair onto the head, placing one end of the seam above the face at the center hairpoint line and stitching along the center seam of hair. Backstitch this seam for extra security.

Angel is the only word in the language that can never be worn out.
Victor Hugo

CHRISTMAS CRACKERS

These traditional English crackers will add a festive note to a Christmas table setting. If you have the time to make them it would be fun to pop little hand-made gifts or perhaps a hand-made chocolate or two inside the cracker. Chinese fortune cookies make another fun filling and, if you are lucky, you may be able to buy "snaps" to make an authentic cracker.

MATERIALS

★ 11¼ × 7in (28 × 17.5 cm) thin card
★ small gifts
★ tissue (paper) hat (optional)
★ hand-written joke or fortune cookie
★ 17 × 8½in (42.5 × 22cm) sheets of a variety of colored papers
★ snaps (optional)
★ glue
★ scissors
★ pinking shears
★ thread
★ ribbon/brocade
★ doilies
★ Angel images from old greeting cards or color photocopies from books

1 Roll the card into a tube, spread glue along one long edge and stick, leaving a ½in (1.5cm) overlap. Hold it firmly until the glue sets and the tube is secure. Cut this tube into three sections: two smaller lengths of tube, 2½in (6cm) and one longer section measuring 6¼in (16cm).

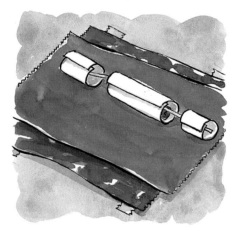

To love for the sake of being loved is human, but to love for the sake of loving is angelic.

Alphonse de Lamartine

2 Place your gift, tissue hat, and joke or fortune cookie inside the longest tube. Position one short tube at each end of the longer one leaving a 1½in (4cm) gap between the sections. Place the rolls along the bottom edge of a colorful sheet of paper. You can cut the edges with pinking shears. Use a spot of glue to secure the rolls in place. If you like the effect of two (or three) colors for your cracker, simply lay shorter widths of paper under the full-width one. If you have snaps, pass these through the tubes at this stage.

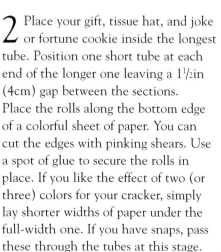

3 Roll the paper around the tubes and glue down the overlap. The paper should hold the card tubes tightly but not so tightly as to squash them. If you are making the two-color paper crackers, you will notice the pretty effect as you start to roll up the cracker.

4 Wrap thread around the crackers at the joins between the smaller tubes and the center tube to pull in the colored paper. Wrap the thread loosely at first then pull more tightly as the paper starts to take on the cracker shape. Tie securely with a knot and cut off any hanging threads.

5 Decorate the top of the cracker with whatever materials you choose. These crackers have ribbon and pieces cut from a gold doily as well as the Angel photocopies, but you could trim your crackers with whatever you have on hand – sequins, lace or fabric scraps, for instance. Stick your trimmings onto the front of the cracker, keeping the glued overlap at the back.

6 Glue your Angel picture over the trimmings to finish the cracker. Here, colored photocopies were used, but you could also use pictures cut from old greetings cards or other Angelic sources.

VICTORIAN ANGEL

This graceful Victorian Angel's simple white robe contrasts with her richly-colored silk wings. The Angel is made from a finely molded body fixed to a hollow cone shape and can stand as a table decoration or on the top of a Christmas tree. The folds of the dress are wired at the hem to give a look of movement to the material.

MATERIALS

★ 2 rectangles of white muslin or gauze, 26 × 10in (65 × 25cm) for skirt

★ 2 rectangles of white muslin or gauze, 4¼ × 3¼in (11 × 8cm) for sleeves

★ 1 rectangle of white muslin or gauze, 20 × 1in (50 × 2.5cm) for bodice

★ 12 × 8in (30 × 20cm) shot silk or lining taffeta for wings

★ 12 × 8in (30 × 20cm) iron-on interfacing for wings

★ 4in (10cm) of ⅜in (9mm) claret satin ribbon for cuffs

★ 20in (50cm) of ⅛in (3mm) narrow gold grossgrain ribbon for headband

★ 20in (50cm) of ⅛in (3mm) narrow claret silk ribbon for headband

★ 14in (35.5cm) of cord to bind the bodice, in white, beige, gold or claret

★ 2 × 26in (65cm) fine wire for skirt

★ made-up doll body and cone base

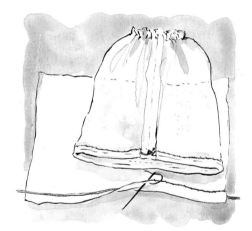

1 Make a narrow hem on both skirt layers, incorporating the wire, either by gluing or stitching. Sew up both side seams. Placing one layer inside the other, gather the skirt at the top and pull tightly around the doll's waist.

2 Trace the sleeve shape onto paper and cut out to form a pattern. Pin the pattern to the fabric and cut two sleeves. Sew up the side seams and slip one sleeve over each of the doll's arms. Run a gathering thread around the top of each sleeve and pull tightly to fit the doll at the shoulders. Do the same at the wrist ends.

3 Cut the satin ribbon in half and glue each half around the doll's wrists to make cuffs.

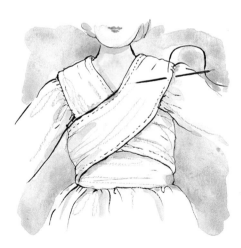

4 Hem the long sides of the bodice strip. Wrap the bodice around the doll's upper body, starting at the rear of her waist and crossing over her chest and back, taking care to cover the skirt gathers. Finish by tucking the ends in firmly at the back.

5 Slipstitch the sleeves to the top edge of the bodice and the skirt to the bottom edge.

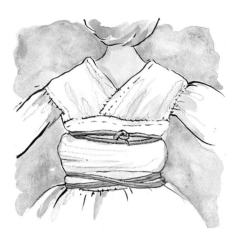

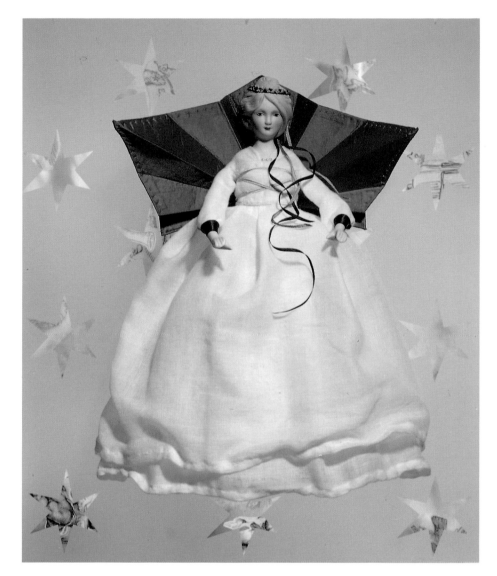

6 Crisscross the cord over the draped bodice and tie at the back.

7 Trace the wing pattern onto cardboard and cut out for a template.

8 Iron the interfacing onto the silk or taffeta. With the interfacing up, draw around the template and cut out the wing. Make a narrow hem for neatness, using tiny running stitches, and press.

9 Fold the wings according to the pattern and steam press the folds with care. Pin or sew the wings to the back of the doll's bodice.

10 Fold the narrow claret and gold ribbons in half. Using the claret silk double as the third strand, braid enough ribbon to form the headband. Tie once around the doll's head with a small knot at the back, and leave the ends trailing over one shoulder.

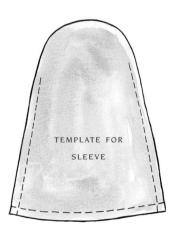

TEMPLATE FOR
SLEEVE

TEMPLATES ARE SHOWN
HERE AT 50%

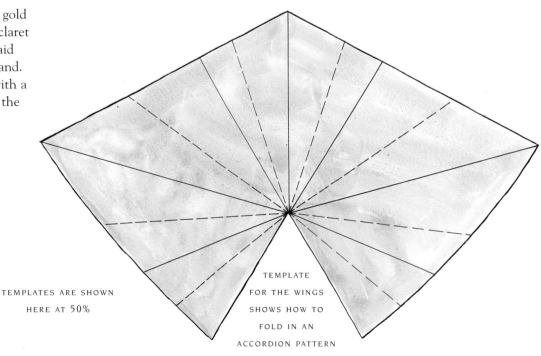

TEMPLATE
FOR THE WINGS
SHOWS HOW TO
FOLD IN AN
ACCORDION PATTERN

Folk

ANGELS

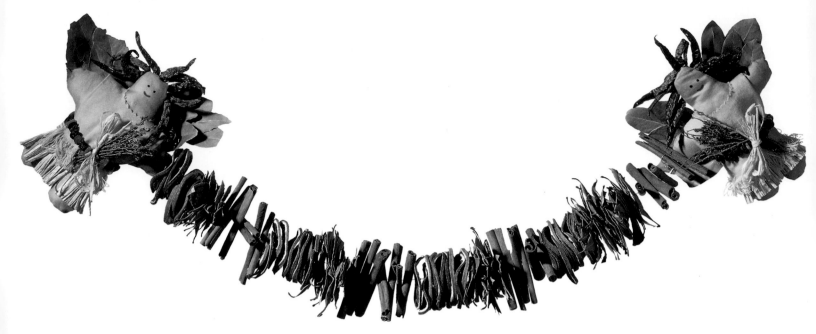

KITCHEN ANGELS

This dried garland is perfect for the kitchen, where it will release the aroma of dried fruits, spices and herbs. If you cannot find dried orange rings in the supermarket, you can easily make your own. Thinly slice several oranges and blot them dry with paper towels. Place on a wire rack and let them dry in a very low temperature oven (e.g. 225° F / Gas '/4/ 110° C). Keep checking the rings until they are absolutely dry — this will take several hours. Allow them to cool before threading onto the garland.

4½IN (11CM)

6½IN (15½CM)

MATERIALS

★ 15 × 10in (38 × 25cm) plain fabric, e.g. calico
★ 2oz (50g) stuffing
★ fabric scraps for tunic
★ 1oz (25g) dried raisins
★ 25 approx. dried red and green chilies
★ 25oz (125g) bay leaves approx.
★ thin wire, 60in (150cm) long
★ 50 dried orange rings
★ 25 cinnamon sticks
★ raffia for under-skirt and trimmings
★ 10 thyme sprigs
★ darning needle
★ fabric markers or fiber-tip markers
★ all-purpose glue
★ thread
★ needle
★ tracing paper
★ pencil
★ paper
★ scissors

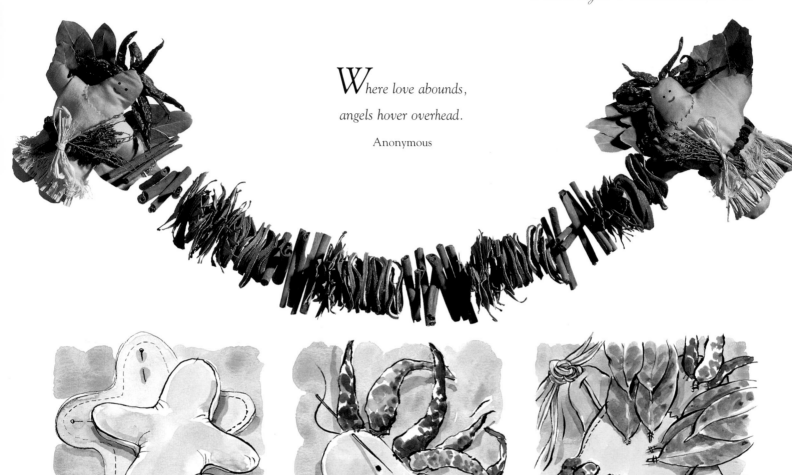

W here love abounds,

angels hover overhead.

Anonymous

1 Make the two Angels first by
enlarging and tracing the template
(left). Place the template tracing onto
the plain fabric, folded double, and cut
out four pieces, to make the backs and
fronts of two Angels. For each angel
put two right facing sides together and
sew around a ½in (1.5cm) seam
allowance, leaving a small gap open for
turning. Turn the Angels right sides
out and fill lightly with stuffing. Hand
sew the gap closed.

2 Cut out a simple tunic dress for
each Angel. Sew up the sides of
the tunic and sew the raw edges around
the neck. Fray the hems by pulling a
few horizontal threads from the fabric.
Slip the tunics over the Angels' heads.
Thread dried raisins onto two strong
pieces of thread and use these as belts.

3 Draw in the facial features with
either fabric markers or fiber-tip
markers. Sew small red and green
chilies around the hairline of each
Angel. (Wash your hands thoroughly
afterwards as some chilies can cause
stinging to the eyes.) Stick bay leaves
together with an all-purpose glue to
make the wings. When they are dry,
stick the wings onto the back of each
doll, secure with a few hand stitches.

4 Thread alternating groups of
orange slices, cinnamon sticks and
bay leaves on to the wire until you
have created a long garland. You will
need a pointed darning needle to make
holes through the cinnamon sticks but
the other ingredients are easier to
thread. Leave 10in (25cm) of wire at
each end of the garland.

5 To attach the Angels to the
garland thread the darning needle
with the end of the wire and sew this
through the back of the hand of one of
the Angels, pass it behind the doll and
sew the wire through its other hand.
Knot the end of the wire. Repeat with
the second Angel on the other side –
remember to make sure that both the
Angels face forwards. Then fasten each
end of the wire into a bow of raffia to
hide the ends. Tuck a small bunch of
thyme into the belt around each
Angel, and tie with raffia to finish.

NURSERY QUILT

This quilt would make a wonderful gift for a new-born baby, and the soft quilted padding makes it perfect for use either in a crib or stroller. Use appliqué techniques for stitching on the patchwork details (see the Appliqué section on pp.24–6). Any fabrics may be used, but contrasting country-inspired check, gingham, plaid, and printed cottons will give an attractive contemporary folk look. Make sure that all the fabrics you choose require the same washing and drying methods.

MATERIALS
★ 85 × 32in (205 × 150cm) cotton fabric
★ scissors
★ fabric scraps
★ sewing machine
★ pins
★ needle & thread
★ 40 × 29in (100 × 73cm) batting
★ 4 × 138in (10 × 350cm) strip of contrasting fabric for border
★ iron

1 Cut out two pieces of fabric 40 × 29in (100 × 73cm). Reserve one piece for the back and work on the other piece for the front of the quilt.

2 From the scraps of different fabrics, cut out a variety of squares and rectangles and sew under the raw edges with a narrow hem. Lay the shapes on the front of the quilt and move them around until you are happy with the overall arrangement. Remove any overlapping pieces from the top, remembering their positions, and pin, then stitch, down the underneath pieces. Replace the top pieces, pin, then stitch in place using a close zigzag stitch on the sewing machine.

Angels at the foot,
And Angels at the head,
And like a curly little lamb
My pretty babe in bed.
Christina Rossetti

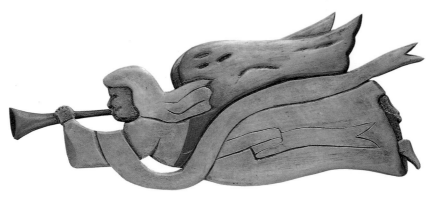

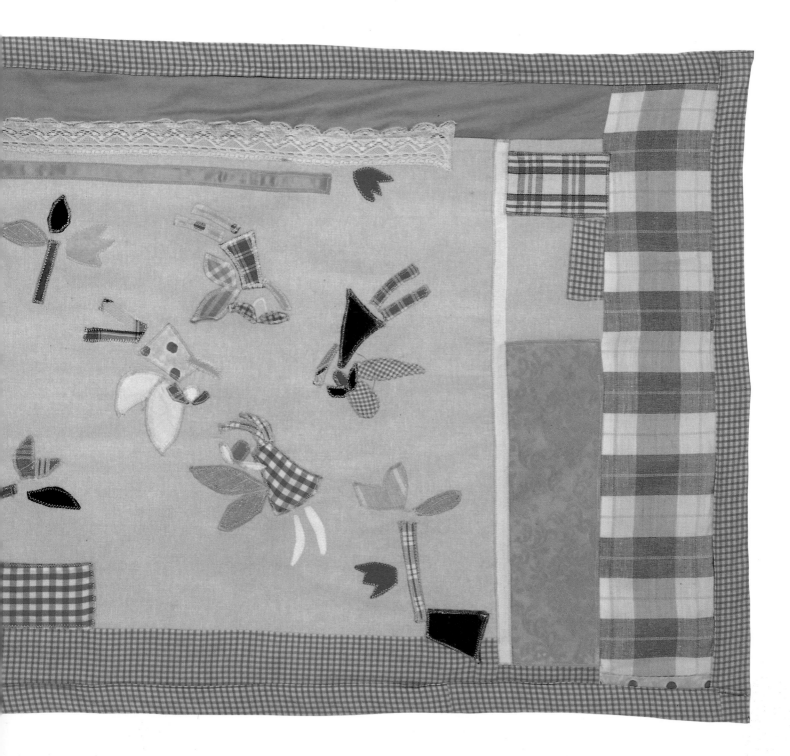

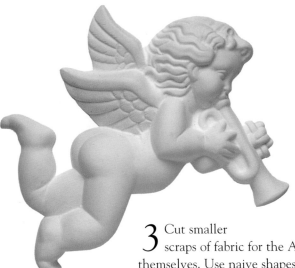

3 Cut smaller scraps of fabric for the Angels themselves. Use naive shapes, such as triangles for their dresses and oval shapes for faces. Arrange the fabric pieces on the quilt as before, moving the pieces around until you decide on their final positions. Pin, then sew, using a close zigzag stitch as before. Felt pieces will not require turning under, but other fabrics will need to be hemmed as before.

5 Sew around all four sides of the quilt leaving a 1in (2.5cm) hem. Trim close to the stitching line. Cut two 4 × 40in (10 × 100cm) strips and two 4 × 29in (10 × 73cm) strips from a contrasting fabric. Turn under and press the raw edges of each border strip.

4 When you have finished the front of the quilt, it is ready to be made up. Cut the batting to the same size as the quilt and layer it between the two pieces, with their right sides out. Pin through all the layers using long pins, including at the center of the quilt so that the pieces will not move when you stitch them together.

6 Pin each strip 1in (2.5cm) in from the outside edge of the front of the quilt, right sides facing. Sew a line of straight stitches close to the strip's edge, then fold each strip over in turn to enclose all the raw edges of the quilt. Keep the narrow hems turned under and stitch close to the edge of the border on the back. Repeat this along all four sides and hand stitch the corners closed to finish.

CROSS STITCH ANGEL

This little Angel is a clever variation on that traditional favorite, the clothespin doll. Just three embroidered cones of Aida fabric and a pair of gold-colored cardboard wings transform a simple clothespin into a tiny Angel dancing on tiptoe. The embroidery is counted cross stitch worked in two colors with the added sparkle of metallic gold thread. A host of these Angels, decorated in various patterns, make a charming mobile to hang above a crib.

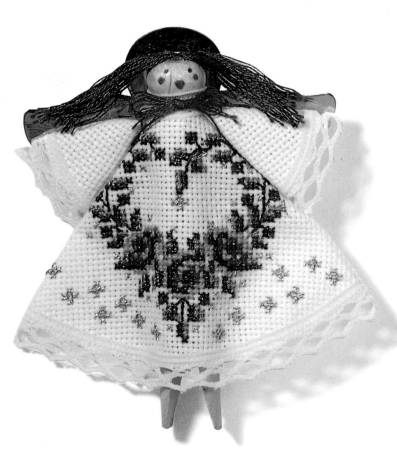

MATERIALS

★ 8 x 4in (20 x 10cm) Aida fabric – a type of needlepoint fabric
★ ½in (12mm) of narrow lace
★ metallic gold floss
★ yellow and blue floss
★ blue floss for bow tie
★ 6-strand brown floss for hair
★ H pencil
★ clothespin
★ fabric glue

1 Cut out the pattern pieces on p.83. Arrange them on Aida fabric so that the weave of the cloth follows the same direction as the grid lines on the pattern pieces. Using an H pencil to avoid smudging, lightly trace the pattern pieces onto the cloth. Make a small mark on the fabric below the arrow on the dress pattern piece. Count up four squares from this point unless otherwise indicated on the graph. This point coordinates with the arrow on the stitching graph on p.83. Begin stitching here. Do not cut out the fabric until you have completed Step 3.

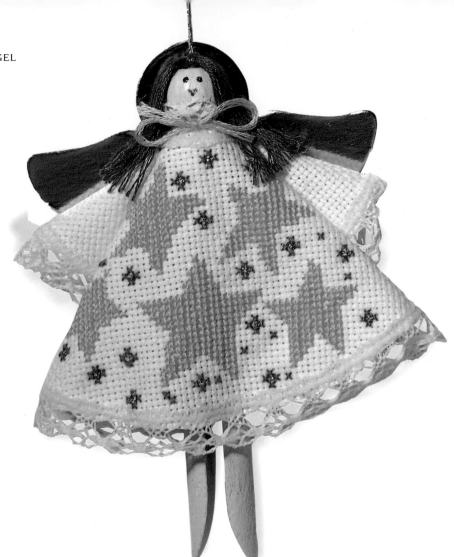

2 Work the cross stitch design using two strands of floss (always work with one unseparated strand of the metallic gold floss) in the colors indicated by the color code. Do not knot your thread. Hold 1in (2.5cm) of thread behind the fabric and secure it by the first two or three stitches you make. To end a thread, run the needle under a few stitches on the back side and clip the thread. Use a stab-stick method to avoid pulling the fabric out of shape. The stab-stick method is done in two steps – straight up, and straight down – keeping the fabric taut. Crossing stitches in the same direction all of the time gives your piece a smooth sheen and an even, finished appearance. Use backstitching and french knots following the specific instructions on the diagram on p. 83.

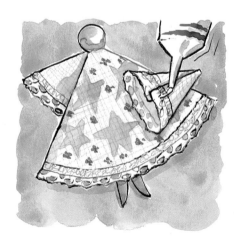

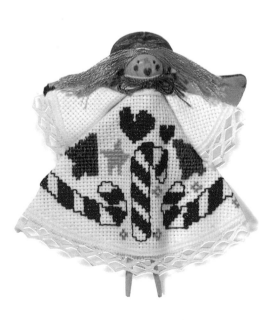

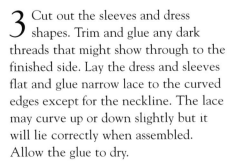

3 Cut out the sleeves and dress shapes. Trim and glue any dark threads that might show through to the finished side. Lay the dress and sleeves flat and glue narrow lace to the curved edges except for the neckline. The lace may curve up or down slightly but it will lie correctly when assembled. Allow the glue to dry.

4 Glue the sleeves at the straight edges to form cones. Wrap the dress around the clothespin and glue at the straight edge. Position the dress so that the Angel appears to have legs. Glue the dress to the clothespin around the neck. Glue the sleeves onto the dress in the arm positions.

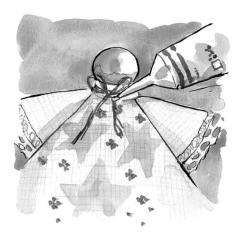

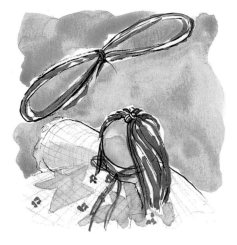

5 Glue a ½in (12mm) length of narrow lace around the neck. Then tie a 6in (15cm) length of blue floss over it in a bow. Apply a dot of glue to hold the bow in place and trim the ends to the desired length.

6 For the Angel's hair, use at least 3 pieces of 6-strand brown floss. Wrap the floss around 3 or 4 fingers, leaving a short length to tie around the center of the wound floss. This will create a tress of hair. Clip both ends of the loops and trim to the desired length and fullness, then glue the knotted center of the hair to the head.

7 Cut out a 1in (2.5cm) circle of gold cardboard and glue to the back of the top of the clothespin to make a halo. Cut out two gold cardboard wing shapes 3 x 2in (7.5 x 5cm). Glue the wings to the back of the Angel's dress where the fabric joins.

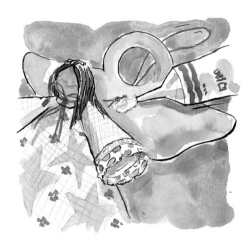

BELOW: STITCHING DESIGN DIAGRAM IS SHOWN AT 85%

ABOVE: FABRIC PATTERN TEMPLATES SHOWN HERE AT 80%

TOP: ¾ STITCH
BOTTOM: CROSS STITCH

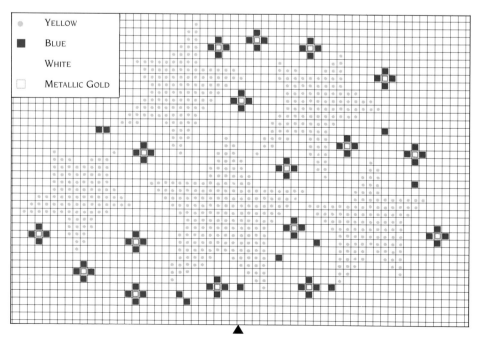

- Yellow
- Blue
- White
- Metallic Gold

COAT HOOK

This charming coat hook will enhance any hallway and gives a welcoming atmosphere to your home. Use the main photograph as a template and enlarge it on a photocopier to the size you require.

MATERIALS
★ carbon transfer paper or tracing paper
★ particleboard
★ poster paint colors: yellow, ocher, black
★ saucer for mixing paints
★ artist's brush
★ scroll saw or electric jigsaw
★ fine sandpaper
★ polyurethane varnish
★ Dutch metal transfer leaf
★ acrylic varnish
★ awl
★ screwdriver
★ three brass coat hooks for the front
★ two small screw-in hooks for the back (for hanging)
★ picture wire or strong nylon fishing line

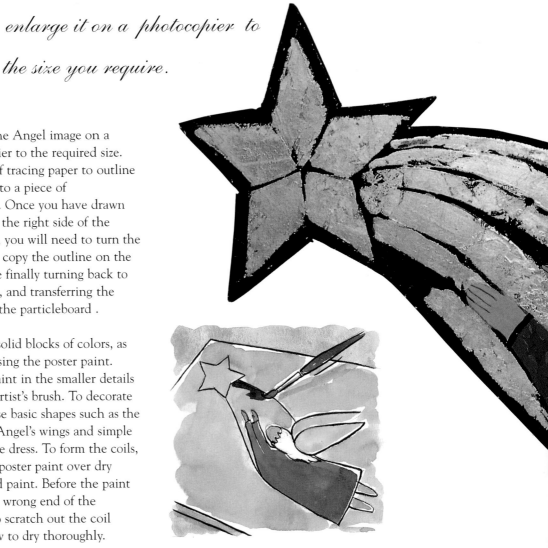

1 Enlarge the Angel image on a photocopier to the required size. Use a sheet of tracing paper to outline the Angel onto a piece of particleboard. Once you have drawn the image on the right side of the tracing paper, you will need to turn the paper over to copy the outline on the reverse before finally turning back to the right side, and transferring the outline onto the particleboard .

2 Paint in solid blocks of colors, as shown, using the poster paint. When dry, paint in the smaller details using a fine artist's brush. To decorate the Angel, use basic shapes such as the coils on the Angel's wings and simple flowers on the dress. To form the coils, paint yellow poster paint over dry ocher-colored paint. Before the paint dries, use the wrong end of the paintbrush to scratch out the coil shapes. Allow to dry thoroughly.

3 Using a fine artist's brush, carefully paint in the facial features. When all the colors are dry, cut the Angel out of the particleboard using a scroll saw or an electric jigsaw. Use fine sandpaper to smooth the rough edges. Paint the back and sides of the coat hook with black poster paint. When dry, protect with two coats of acrylic varnish.

4 To create a shiny gold shooting star, either paint in gold or use gold leaf Dutch metal transfer sheets. Paint a layer of acrylic varnish over the shooting star. Let it dry until slightly tacky. At this stage, press the gold transfer leaf over the surface and rub the gold with your finger to adhere it to the surface. Repeat this process until the star is completely covered. When the star is dry, protect and seal the surface with two or three layers of acrylic varnish.

5 When the coat hook has been decorated, screw the three brass coat hooks onto the front.

Turn the hook over and screw two small hanging hooks into the back near the top edge. Make sure the screw thread does not penetrate through to the front. Tie a length of picture wire or strong fishing line between hooks.

Alternatively, you could screw the whole coat hook directly onto the wall as you would any wall plaque and paint the ends of the screw to blend into the design of your Angel.

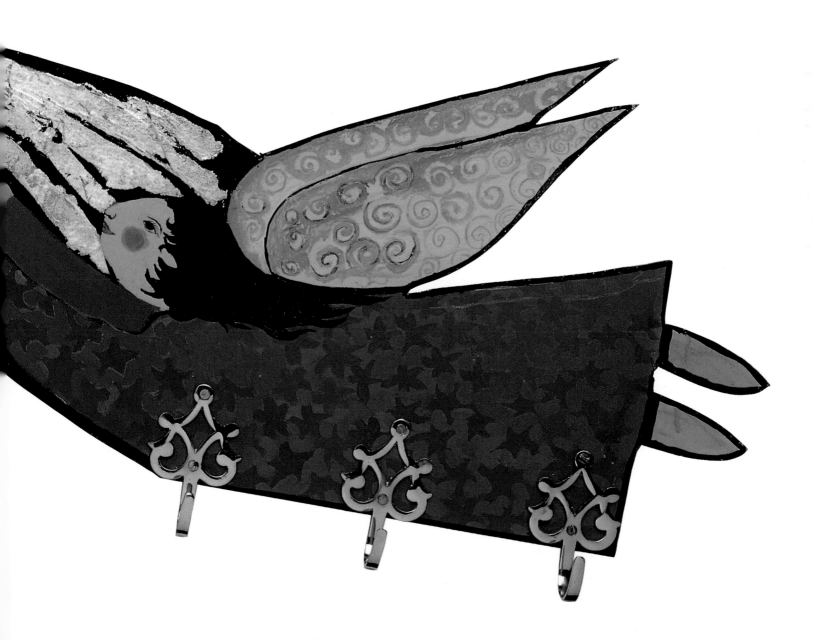

RAG DOLL

This cloth doll is quite literally made from scraps and rags of fabric. Her raffia hair gives her a perfect country charm and the oddly matched buttons add to the look. You can make accessories for the doll, too, if you want to make her for a special gift or occasion. The pot of dried flowers turns her into a Thanksgiving gift, while an alternative dress can make her into a Nurse for a relative in a caring profession, or it can be adapted to any outfit of your choice.

MATERIALS
★ tracing paper
★ pencil
★ fabric scraps –
cream thick cotton,
or other plain,
woven fabric
★ sewing machine
★ thread
★ scissors
★ stuffing
★ needle
★ ribbons
★ brocade
★ buttons
★ felt
★ raffia
★ fabric pens or
fiber-tipped
markers

1 Trace the templates on p.88 and cut out the cotton fabric. You will need to cut two body shapes and four arms. Put right sides of fabric together – making one body and two arms – and machine sew along the ½in (1.5cm) seam allowances using a straight stitch. Leave a small gap on each piece so that you can turn it through to the right side.

2 To make it easier to turn the pieces out, clip any curves, snipping the fabric close to the line of stitches. Turn each piece out to the right side and fill firmly with the stuffing, using a blunt pencil, if necessary, to push it in. Hand sew the gaps closed with tiny overstitches. Sew the arms onto the body using tiny handstitches.

3 Use the rag doll body to cut out the pattern for the dress bodice. Draw two sleeves at the point where the arms are stitched to the body and scoop a neckline where the top of the dress would finish. Remove the bodice pattern and use it to cut out two double-thickness pieces of fabric. With right sides together, stitch around the seams. Turn to the right side and sew all the raw edges closed and decorate with trimmings.

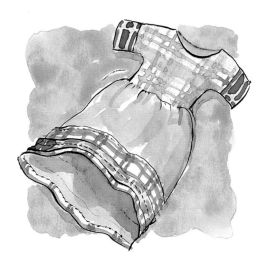

4 Cut a skirt piece from another fabric scrap, approximately 12 × 7in (30 × 18cm). Sew the long seam together to make a tube and gather in the top to fit into the bodice. With the right sides together, sew the skirt to the bodice. Sew the bottom hem and decorate with a colorful band of another fabric with an additional ribbon, complement the sleeve edging. Hem all raw edges neatly. Sew on brocade and buttons to finish and fit over the doll.

5 Use the doll pattern again to cut the felt shoes. You will need four foot shapes. Sew two together and turn to the right sides. Repeat with the other two. Fasten them onto the doll's legs, using a tiny button at the front of each shoe. Sew small bunches of raffia onto the back of the doll's head as hair. Smaller tufts should be sewn onto the forehead for her bangs.

6 Paint on the features using fabric pens or fiber-tipped markers – but remember that marker colors will not stay fast in the washing machine. Sew on a small halo of brocade.

Trace the Angel wing template, cut out the Angel wings from double thickness fabric and sew around the seams, as before. Turn each wing to the right side and stuff with just a little filling – do not fill them as firmly as the rest of the doll. Hand sew the wings onto the back of the doll using tiny "invisible" stitches.

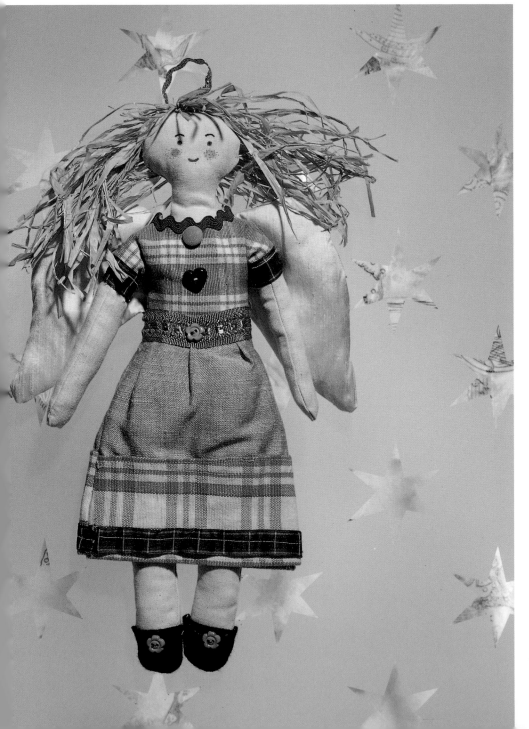

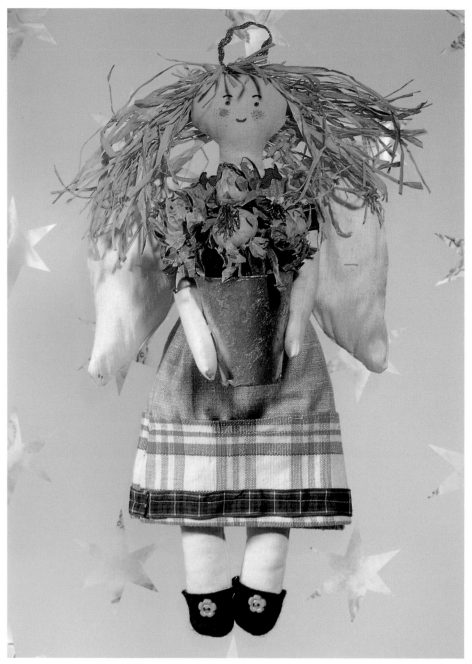

THANKSGIVING GIFT

Rub gilding cream all over a tiny terracotta flowerpot and fill the pot with stalks of wheat or short, dried flowers. Glue the wheat or flowers in place or push the stalks into the small piece of dry oasis glued firmly to the base of the pot. Wire the flowerpot between the arms of the Angel doll for a Thanksgiving gift.

MATERIALS
★ gilding cream
★ terracotta flowerpot
★ dried stalks of wheat or flowers
★ glue
★ dry oasis
★ fine wire

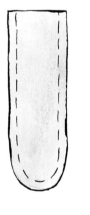

TEMPLATES SHOWN HERE AT 100%

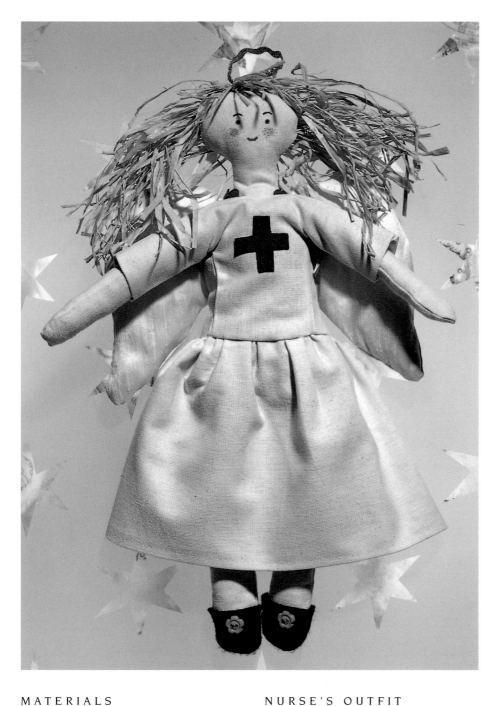

3 Make a second template and cut it in half. Pin the templates onto a single thickness of fabric – add ½in (1cm) to the width at the center. Cut out the two back bodice pieces. Turn under the center seams and sew neatly.

4 Pin the front piece to the two back pieces, right sides together, and sew the side seams to the wrist, and the top arm seams to the neckline. Hand stitch hems to the neckline and cuffs.

MATERIALS
★ 12 x 12in (30 x 30cm) muslin or other scraps of fabric
★ sewing machine
★ all-purpose glue
★ thread
★ scissors
★ tracing paper
★ grippers
★ pencil

★ needle & thread
★ 1 x 1in (2.5 x 2.5cm) red felt for cross. Or scraps of fabric to make other accessories such as an apron for a "Cooking Angel" Rag Doll
★ tracing paper

NURSE'S OUTFIT

1 Bodice: On tracing paper, draw around the rag doll's body, from the neck down to the wrist, then along the underneath of the arm and down the sides to the waist, allowing for seams. Repeat on the other side. Remove the doll and join the lines across the waist and wrists; make a slightly scooped neckline.

2 Cut out the tracing pattern and pin it to a single piece of fabric. Cut out one piece for the dress's front.

5 Skirt: Cut two 10 x 7in (25 x 18cm) rectangles from a double thickness of fabric. Sew up narrow side seams. Run a long gathering stitch around the top of this skirt and pull the threads to fit inside the waist of the bodice. Sew the skirt's seam and hem.

6 Sew grippers onto the overlapping seams of the back of the bodice. Cut a cross from red felt and glue onto the front.

CLOTHESPIN ANGELS

These fun clothespin dolls can be dressed with scraps of fabric and pieces of ribbon or lace. The old-fashioned wooden clothespins are definitely the best. Alternatively, make your own, using a wooden bead and a short length of doweling. You simply glue the bead onto the end of the doweling. Use these Angels as decorations for a Christmas tree.

MATERIALS

★ wooden meat skewers or toothpicks
★ scissors
★ all-purpose glue
★ clothespins
★ needle & thread
★ fabric scraps e.g. silk or brocade
★ sewing machine
★ black fiber-tipped marker
★ 3in (7.5cm) wide piece of cardboard
★ 120in (304cm) gold (metallic sewing) thread
★ ribbons, buttons or beads
★ gold doilies

1 Cut a piece of wooden skewer 5in (12.5cm) long or glue two toothpicks together and secure with scotch tape around the join. Glue this horizontally to the clothespin at the point where the round head starts. Secure the two pieces together using a figure-eight movement with thread, so the skewer is held firmly at the back of the clothespin. Leave the doll body until the glue has dried.

2 Cut a 10 × 5¹/₂in (25 × 13.5cm) rectangle of fabric for each Angel's dress. Fold the fabric in half across its width and sew the two side seams. Hem the raw edges and decorate with lace or ribbon. Cut a small hole in the center of the fold and push the doll's head through. The arms should tuck neatly inside the fold of the dress.

3 Use a sewing machine to sew lines of stitches as close as possible to the doll's body and arms. Draw the features of the Angel onto the head using a black fiber-tipped marker. Steady your arm against a table as you do this to prevent uneven lines.

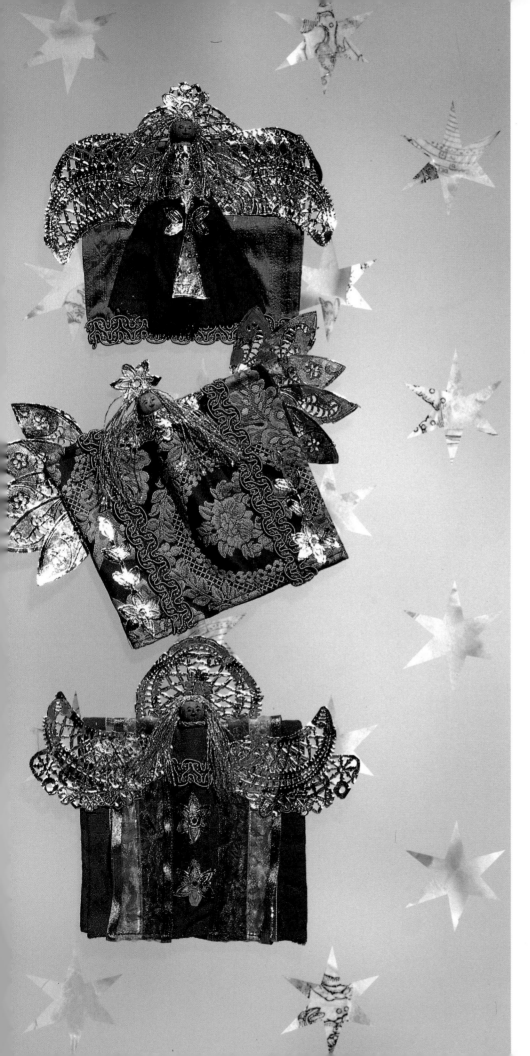

4 To make the glittery Angel hair, wind at least twenty coils of gold thread around the piece of cardboard. Remove the cardboard and secure the coils at the center with a knot of gold thread, snipping the ends of the hair with sharp scissors. Glue this bundle of hair, with the knot as the central point, to the top of the doll's head.

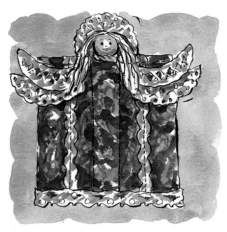

5 Decorate each Angel using whatever trimmings you have to hand. Ribbons and lace look effective, or you could use buttons or beads, if you wished. Glue parts of the gold doilies onto the Angel for the halo and the wings. Smaller parts of the doilies can be used to decorate the dress. Tie gold thread around the neck of the Angel and secure with a knot at the top for hanging on a Christmas tree.

I want to be an angel,
And with the angels stand
A crown upon my forehead,
A harp within my hand.

Urania Locke Bailey

SALT DOUGH TREE DECORATIONS

Salt dough is easy to make from basic ingredients and can be cut into almost any shape. In this case, the rolled-out dough was cut into a shape that would contain the Angels. Simply trace around your source image and use this as a template for your salt dough. The detailed features and clothing taken from the tracing make the final decoration look finely painted. In fact, the outline is simply colored in – it couldn't be easier!

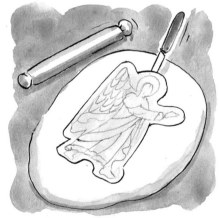

MATERIALS

★ salt dough (see recipe on p.27 to make the quantity you want).
★ rolling pin
★ tracing paper
★ pencil
★ scissors
★ sharp kitchen knife
★ baking tray or sheet
★ tempera paints, including gold
★ fine brush
★ acrylic varnish
★ all-purpose glue
★ ribbon

1 Follow the recipe instructions in the *Salt Dough* section (p.27) to make up the amount you require. Knead the dough until smooth, then roll it out on a flat surface until it is approximately ¼in (0.5cm) thick. You will find that the dough is quite elastic and firm and should not stick to the work surface at all.

2 With a pencil, trace around the Angel image that you have chosen for your decorations – you may wish to create several different Angels or perhaps just one – or use the template on p.93. Remember to include any details for the clothing, wings or facial features on your tracing.

3 Cut out your tracing and place it on the salt dough. Use a sharp knife to cut out the shape in the dough, pulling away any excess dough from around the shape. Roll this out once and repeat until you have used up all the salt dough.

4 Lift each shape carefully and place on a baking tray in a very cool oven 110°C/225°F/Gas ¼. Bake for approximately eight hours. Check that the shapes are completely dry and remove them from the oven.

5 Once cooled, put the tracing on the smooth side of the dough – in most cases this will be the top rather than the side that was touching the baking tray or sheet. Carefully trace the details on and paint in the colored parts. Paint over the pencil outlines with gold tempera paint, and also add gold highlights to the wings and halos.

6 Varnish each Angel and glue a small loop of ribbon on the back of each decoration. Leave until the glue is completely dry before suspending the decorations from your Christmas tree.

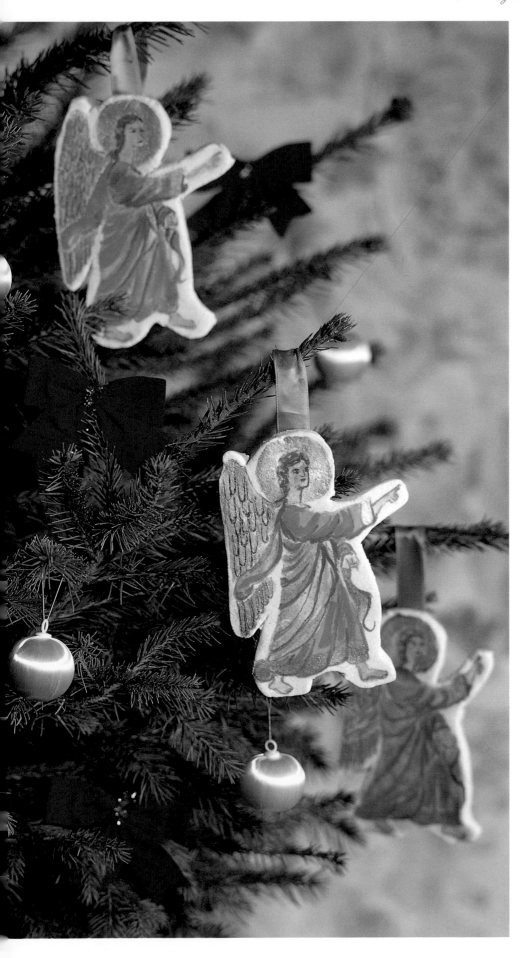

TEMPLATE SHOWN HERE AT 50%

BABY ANGEL RAG DOLLS

These small rag dolls are quick and easy to make, and you can personalize them to suit the recipient. Use one of the ideas here or develop your own designs. Just two basic pattern pieces are needed to create these versatile pocket dolls, yet each has a personality of its own. Simple and inexpensive to make, they are irresistible to adults as well as children. Use a single doll as a gift to mark a suitable occasion, or put them together in a charming trio.

MATERIALS

STAR ANGEL

★ 12 × 18in (30 × 46cm) of cotton fabric or thick muslin for body
★ two blue beads for eyes
★ 10in (25cm) of narrow gold cord for hair
★ 1oz (25g) of ⅛in (3mm) wide cream nylon knitting ribbon for hair
★ 2oz (50g) polyester stuffing
★ blue stranded embroidery floss for face details
★ 10 × 20in (25 × 50cm) of white cotton fabric for dress

★ 36in (1m) of gold trim
★ 8 × 12in (20 × 30cm) of white organza for the wings
★ gold sequins to decorate wings and hair
★ 36in (1m) of ½in (12mm) wide gold ribbon for neck and wings
★ 6 white pipe cleaners for wings
★ fabric glue

HEAD AND BODY – FOLLOW FOR ALL DOLLS

Copy the template on p.96 and cut out the body fabric. With the right sides facing, machine stitch around the body, leaving the seam open as indicated on the pattern. Trim the seam allowance and clip the seam at the neck, arms, and between the legs. Turn right side out. Stuff evenly, using a large knitting needle to help push the filling in place. Turn in the seam allowance and overcast the opening to close.

STAR ANGEL DOLL

1 Make a doll from cotton or muslin following the materials list and the instructions above.

2 For the hair, wind the knitting ribbon around a piece of cardboard 5in (12.5cm) deep, dividing it into two separate skeins. Tie each skein firmly around one end, and remove from the board. Overcast the two skeins to the center of the head, so that they fall onto each side of the face. Glue along the hairline and secure with the narrow gold cord around the head. Hold the cardboard in place by stitching a sequin to the center part, as shown.

For the eyes, hand sew the two small beads in place. Then use one strand of embroidery thread to make a straight stitch for the nose and a french knot for the mouth.

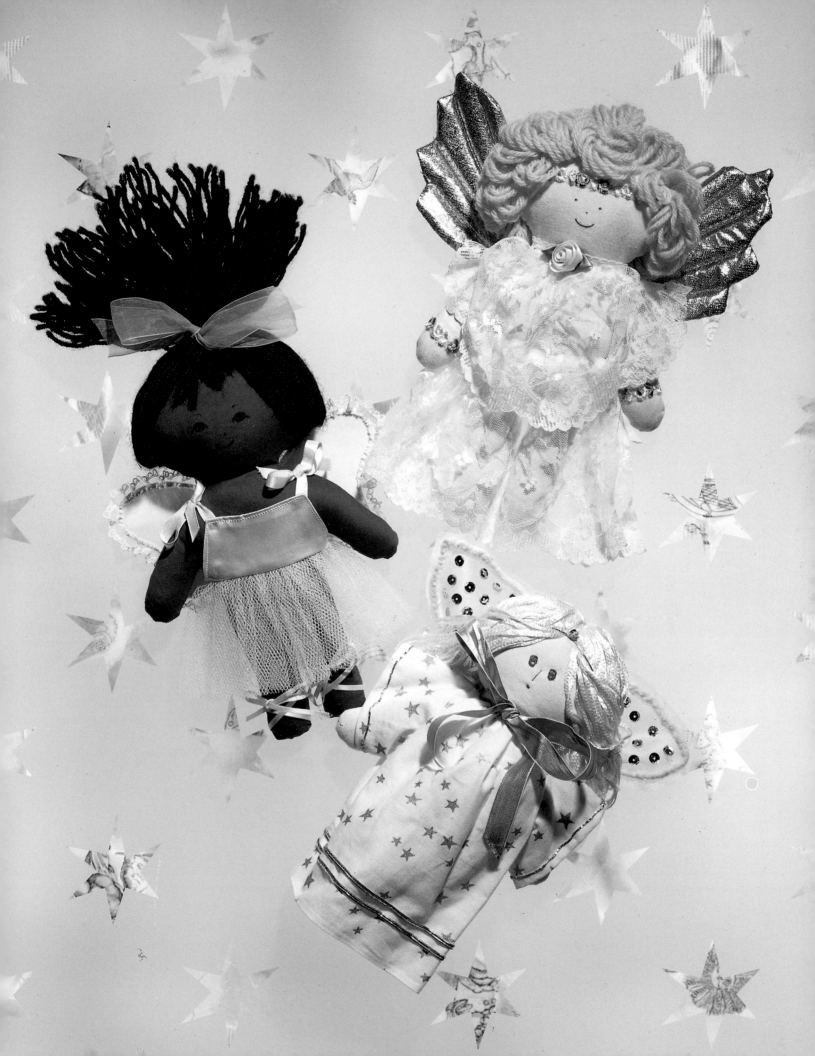

3 To make the dress, double over the white cotton fabric and cut out two squares of 6¾ × 6¾in (17 × 17cm) and two strips 2½ × 5¼in (6 × 11 cm). Follow the layout pattern on p.97.

4 Pin the two dress pieces together, right sides facing, three-quarters of the way up from the bottom. Fold the two sleeve strips in half and pin them, right sides facing, into the gaps you have left either side of the top of the dress – the raw edges should be at the top. Machine stitch the side seams of the dress pieces together and continue the seam up each half of the sleeves so that you end up with a T shape.

5 Pin the open top edges of the sleeves together, leaving a gap for the doll's head. Stitch the seams up to the gap. Use a gathering stitch around the gap for the neckline to draw closed.
 Press all the seams open and hem the cuffs of the sleeves and bottom of the dress. Turn right side out.

★ ★ ★ ★ ★ ★ ★

Note for assembling body:
You must remember to leave the gap marked at the top of the head open as this is where you will turn the doll shape right side out and put the stuffing inside.

★ ★ ★ ★ ★ ★ ★

6 Using the wing pattern (see p.98) as a template, join the ends of three pipe cleaners by twisting, and mold them to the required shape. Repeat for the second wing. Cut two wings from the organza and glue the pipe cleaners in place. Glue the sequins to decorate each wing. Overcast the wings together at the center point and stitch them to the center back of the doll. Cover the join with a ribbon bow.
 Cut a 20in (50cm) length of gold ribbon and tie in a big bow around the doll's neck.

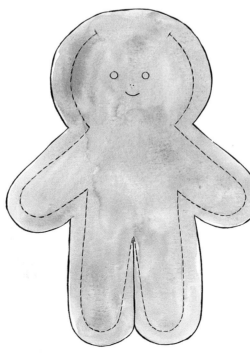

TEMPLATE SHOWN AT 50%

★ ★ ★ ★ ★ ★ ★

Note for dresses

Wash and press the main fabrics to test for shrinkage and colorfastness before cutting the fabrics.

Note for making the Angel bodies

Seam allowances are included on the doll body pattern. Stitch and trim back to ¼in (6mm), snip into curved seams and press open.

★ ★ ★ ★ ★ ★ ★

ALTERNATIVE DRESS

1 Enlarge the template on p.97, and trace it onto paper and add the markings. Pin the pattern on folded material and cut two pieces.

2 Pin the two dress pieces together with the right sides facing, and machine stitch the side seams leaving a gap for the sleeves. Press the seam open. Pin the sleeves to the main dress, right sides together. Stitch the seams.

3 On the front and back pieces of the dress, make a ½in (12mm) double turning along the neck edge to form a casing. Thread the elastic through both casings to fit the neck, and overcast the ends together. Pin and machine stitch a ¼in (6mm) hem along the bottom of the dress to finish.

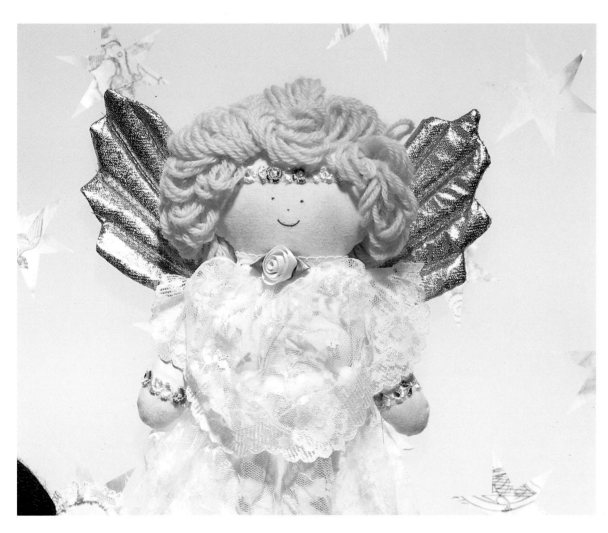

MATERIALS
BRIDE

★ 12 × 18in (30 × 46cm) of plain cotton or thick muslin for body

★ 1oz (25g) of yarn for hair

★ 2ox (50g) polyester stuffing

★ fine fiber-tipped markers (red and black) and blusher for face

★ 36in (1m) of 5in (12.5cm) wide lace, with one bound edge, for dress

★ 9¹⁄₂in (24cm) flower-embroidered trim for head and wristbands

★ 9 × 12in (23 × 30cm) of gold metallic bonded or woven fabric for wings

★ 9 × 6in (23 × 15cm) of interfacing for wings

★ two satin ribbon flowers

★ 14in (36cm) of round elastic

★ ruler

★ pencil

ABOVE: CUTTING LAYOUT FOR STAR ANGEL

ANGEL BRIDE DOLL

1 Make the doll from cotton or thick muslin following the materials list above and instructions on p.94.
Draw the face using the black marker for the nose. Suggest the cheeks with a light dusting of blusher.

BELOW: TEMPLATE SHOWN AT 50%

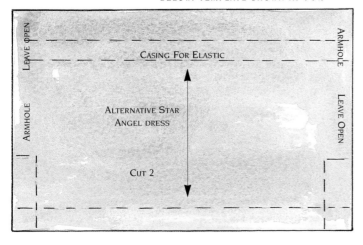

LEAVE OPEN

ARMHOLE

CASING FOR ELASTIC

ARMHOLE

LEAVE OPEN

ALTERNATIVE STAR ANGEL DRESS

CUT 2

2 To make the hair, cut a long piece of yarn and wind it around a ruler. Back stitch along the top edge to hold the loops together. Slip the loops off the ruler and hem stitch in place in rows across the head, beginning at the base of the neck. Repeat until the head is completely filled. For smaller curls, wind the yarn around a pencil.

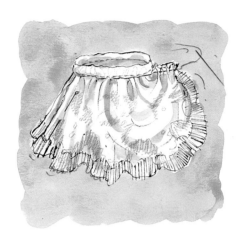

3 Cut the dress lace in half to make a separate skirt and top. Cut 8in (20cm) of elastic for the waist and 6in (15cm) for the neck. Thread the 8in (20cm) of elastic through the binding on one of the pieces of lace and knot the ends together. Fit this skirt on the doll with a center back opening. Thread the other piece of elastic through the remaining lace to make the top of the dress. On this piece, join the raw edges together with a line of running stitches, and then pull them up to make a finished shoulder width of about 2in (5cm). Repeat on the opposite shoulder.

4 Sew the ¹/₂in (12mm) wide lace around the neck by hand and glue one of the flowers to the center front. Cut 3¹/₂in (9cm) of the flower-embroidered trim and sew straight across the doll's forehead to form a headband. Conceal the ends inside the curls on either side. Cut the remaining trim in half and sew one strip around each wrist like a bracelet.

5 Trace the wing shape onto cardboard and cut out to form a template. Fold the gold metallic fabric in half, right sides together, to form a rectangle 9 × 6in (23 × 15cm). Place the matching rectangle of interfacing on one side of the folded fabric and pin all three layers together. Position the wing template on the interfacing and

draw around it with a pencil. *Do not cut out yet*. Stitch around the shape through all of the three layers, leaving ¹/₄in (5mm) seam allowance. Cut out with sharp scissors along the penciled line. Snip the seam allowance to ease curves and sharp angles, turn right sides out, and oversew the opening. Top stitch with four lines of stitching following the pattern. Attach to the back of the doll at shoulder level.

ALL TEMPLATES SHOWN
HERE ARE AT 80%

MATERIALS

BALLERINA ANGEL

★ 12 × 18in (30 × 46cm) of plain cotton or thick muslin for body
★ 8in (20cm) long yarn for hair
★ polyester stuffing
★ 36in (1m) of 4in (10cm) wide pink net for tutu and wings
★ 7in (18cm) square of matching pink satin or cotton fabric
★ 7in (18cm) square of thick, iron-on interfacing
★ 36in (1m) of pink lace trimming
★ ribbon for hair
★ fabric glue

BALLERINA ANGEL

1 Make the doll as usual from cotton or thick muslin following the materials list here and the instructions given on p.94.

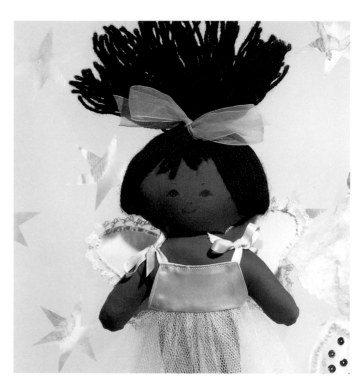

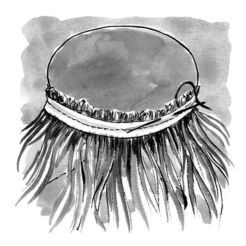

2 To make the hair, sew bunches of wool onto a 5in (12.5cm) piece of ribbon. Starting from the side of the head attach at base of head as shown. When the hair piece is secure gather together in a ponytail at the top of the head and tie with a ribbon. You can add bangs with scraps of wool.

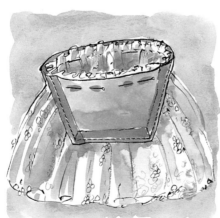

3 To make the tutu, cut two pieces, 3 x 1½in (8 x 4cm), of pink satin. Gather the length of pink net and pin on each piece of satin as a back and front panel. When you are satisfied with the fit, sew the satin and net together. Add two ribbon straps and fit onto doll.

4 Trace the wing shape onto cardboard and cut out to form a template. Iron the interfacing to the pink fabric. With the interfacing uppermost, draw around the template *twice* and cut out both shapes. Gather most of the lace trim to surround one of the shapes completely and sew it to the pink fabric side, using tiny running stitches as close to the edge as possible. Spread fabric glue on the interfacing side of the untrimmed pair of wings. Bring both pairs together, pink sides out, and smooth firmly. Allow to dry before stitching to the back of the doll's tutu. Conceal the stitches with a small bow of the pink lace trim.

REPOUSSÉ METAL FOIL ANGELS

Lightweight metal foil is surprisingly simple to cut and emboss with a relief pattern, known as repoussé work. No special skills or tools are needed and the results can be stunning. The foil is available in rolls from good craft stores, or from sheet metal suppliers. It is thin enough to cut with regular household scissors. The decorative relief is created by drawing on the back of the foil with a dry ballpoint pen. Press fairly hard with the pen to indent the foil, and the design will appear as an embossed pattern on the other side. The metals used here are brass, aluminum, and copper.

These shimmering Angels would look extremely effective dangling from a Christmas tree. Try them as part of a themed decoration, alongside gold or silver baubles and matching metallic ribbon bows. Or attach a single Angel to the front of a handmade greetings card. You could even glue some Angels to a painted wooden picture frame to create an impressive gift.

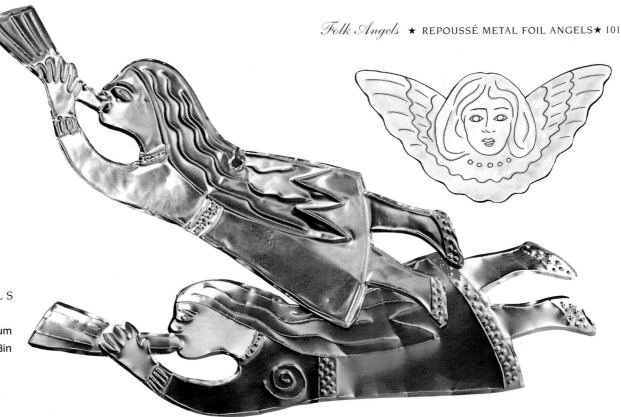

MATERIALS

★ pieces of copper, aluminum and brass foil, 8in (20cm) square (004-gauge)

★ tracing paper

★ scotch tape

★ small, pointed scissors

★ dry ballpoint pen

★ awl

★ pencil

★ old magazine

1 Trace the template design on p.101 using the tracing paper and pencil. You can reduce or enlarge the template to suit. For this project each foil Angel was cut from 8 × 8in (20 × 20cm) foil.

2 Place the tracing paper design over the metal foil and secure with scotch tape.

3 Put an old magazine under the foil to provide a soft surface. Use the ballpoint to draw over the image on the tracing paper, pressing just enough to transfer the design to the metal. Remove the tracing paper.

4 The Angel will appear in the form of slightly indented lines on the surface of the metal. Draw over these again with the ballpoint, pressing much more heavily.

5 Cut out the Angel with the scissors, allowing a margin of 1/16in (2mm) beyond the outside edge of the design.

6 Use the awl to punch a hole through the top of the Angel, so that you can thread fine wire through to make a hanging loop.

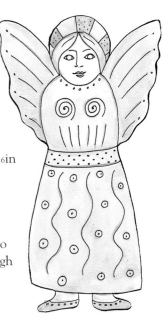

Contemporary Angels

ANGEL IN FRAME

This is a great project for utilising all those scraps of fabric that we are often tempted to throw away. Refer to the Appliqué section on pp.24–6 for more information on the techniques involved and other great appliqué ideas. To give your Angel in frame an added twinkle, try to use a few sparkling fabrics and interesting trimmings.

MATERIALS
★ scraps of fabric, e.g. cotton, organza or canvas, in similar tones, for the background
★ needle and thread
★ organza for the background, 11 × 11in (28 × 28cm)
★ scraps of cotton fabric for the Angel
★ felt
★ gold braid for the headdress
★ scissors
★ needle pins
★ pinking shears
★ embroidery threads
★ gold thread
★ beads
★ sequins
★ two-sided adhesive tape
★ pre-made box frame

1 Arrange a patchwork background using three pieces of fabric in the same tones, to make an overall piece 10 × 10in (25 × 25cm). Sew them together. Do not worry about rough edges and uneven lines. Overlay the patchwork with a piece of organza, allowing it to overlap the edges.

2 Cut out fabric pieces for the Angel using the main photograph as a template. Cut out some pieces with pinking shears to create interesting edges. Pin or baste the Angel pieces onto the background to hold in place.

3 Embellish the picture using an assortment of embroidery threads, with different stitches, such as cross stitch and stab-stick. Sew a piece of braid on the Angel's head, then sew sequins onto the border of the dress.

4 Embellish with beads and sequins. Sew a piece of cord along the join of the organza and the Angel panel.

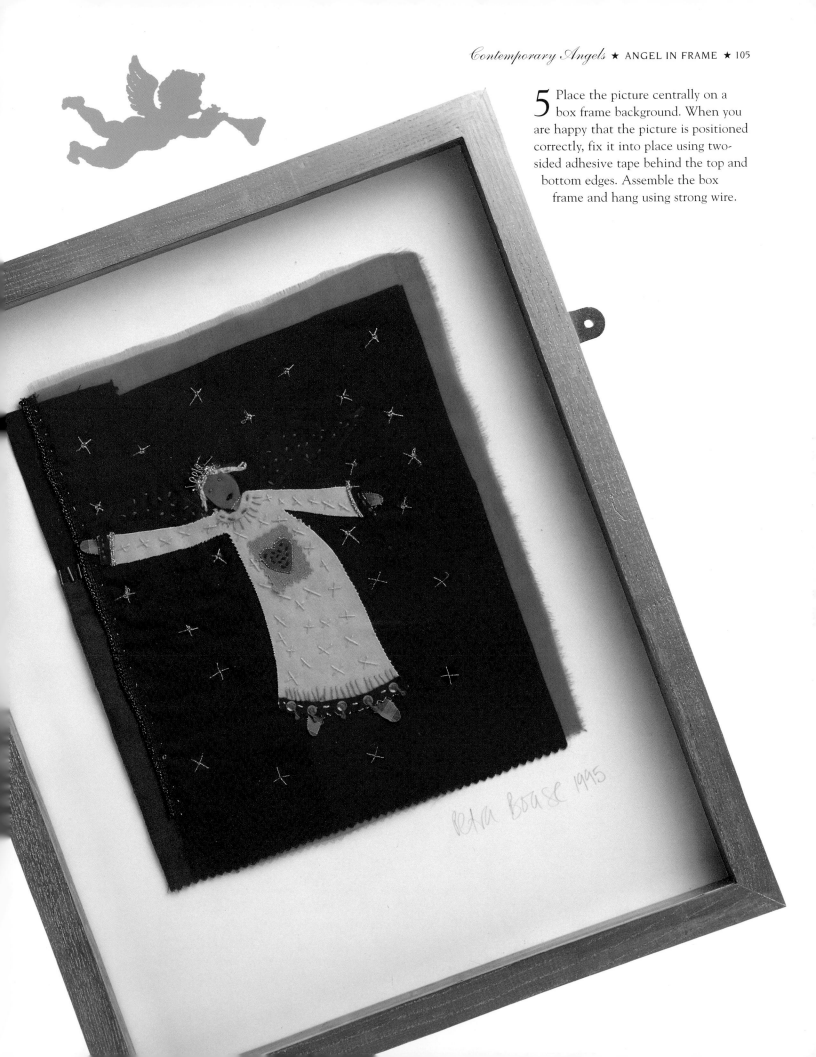

5 Place the picture centrally on a box frame background. When you are happy that the picture is positioned correctly, fix it into place using two-sided adhesive tape behind the top and bottom edges. Assemble the box frame and hang using strong wire.

ANGEL PILLOW

This little pillow will make any chair or bed look special. If you want to make it larger, simply enlarge the Angel templates on p.108. When you need to clean the pillow, have it dry cleaned or wash it in cold water with a light detergent.

MATERIALS

★ 12½ × 12½in (32 × 32cm) velvet for the front of the pillow case
★ scissors
★ iron
★ adhesive interfacing
★ fabric glue
★ paintbrush
★ pencil
★ embroidery threads and needle
★ braid
★ 12 × 12in (30 × 30cm) pillow pad
★ 12½ × 8½ in (32 × 22cm) fabric for the back of the pillow
★ sewing machine
★ ribbon
★ pins
★ 4 pom-poms
★ buttons

1 Cut out the piece of velvet or other fabric for the front of the pillow cover. Iron adhesive interfacing onto the reverse side of the fabric pieces you are using for the Angel image.

2 Draw around the templates (see. p.108) on to the interfacing and cut out the shapes. Press them onto the front of the pillow with a warm iron. If you are using velvet, put a piece of cotton fabric between the iron and the appliqué shapes.

3 Decorate the Angel with an assortment of embroidery stitches and pieces of braid and ribbon. Sew the wings with a line of running stitch.

4 Use fine embroidery threads and delicate stitches for the face. For the hair, use a loop stitch to create a curly effect.

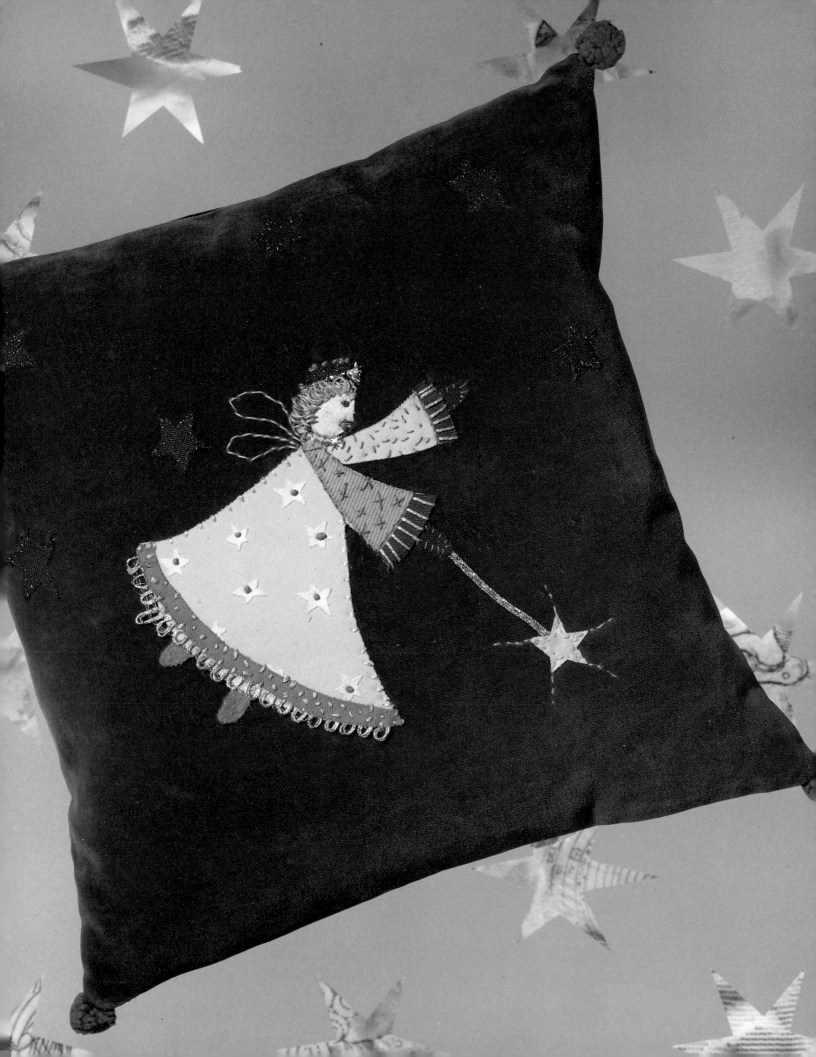

5 Cut out the two pieces of fabric for the back of the pillow. Fold over one of the long sides to make a seam and sew. Place the two back pieces onto the front Angel appliqué piece, with right sides facing. Pin together and sew around the whole square with a ½in (1cm) seam allowance.

6 Snip the corners of the square and turn it right side out. Sew a pom-pom onto each corner of the square. Sew a row of buttons on the reverse of the pillow along the overlap edge.

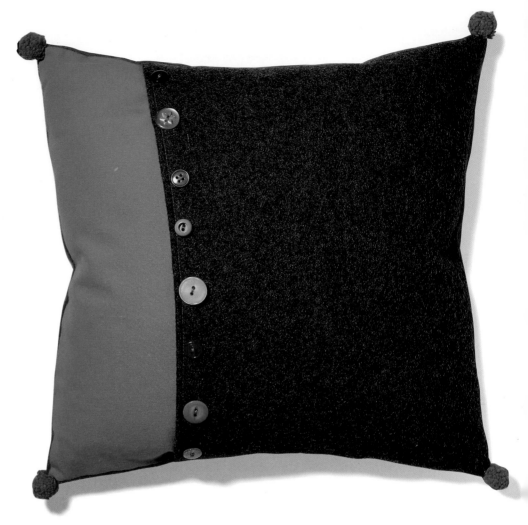

THE BACK OF THE PILLOW

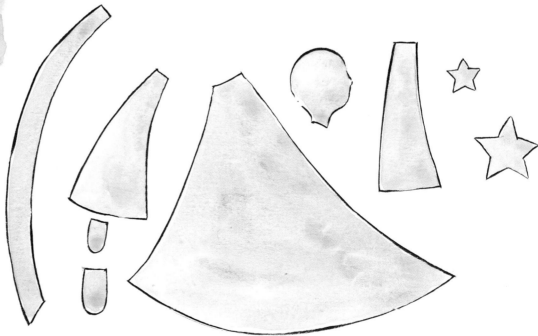

TEMPLATES SHOWN HERE AT 100%

PAPER-CAST ANGEL MEDALLIONS

These ceramic cookie stamps have been cleverly adapted to make charming paper-cast medallions. This technique produces unique results but it is deceptively easy and accessible to adults and children alike. All you need are a few scraps of white writing paper and some simple kitchen equipment. The white medallions have been subtly mounted onto a lacy white doily which has, in turn, been mounted onto a folded card of hand-made paper. The matching chiffon ribbon makes this a really special greetings card — a must to create for the holidays. Unmounted, these delicate little medallions would look especially beautiful hung from the branches of a Christmas tree a — perhaps interspersed with other seasonal white and silver decorations.

MATERIALS

★ 4 sheets of white writing paper
★ saucepan
★ 2 pints (1.2 litre) water
★ electric blender
★ toothbrush
★ cooking oil
★ ceramic cookie stamp
★ soap
★ dish towel
★ small spoon
★ cookie sheet or baking tray
★ doily
★ scissors
★ all-purpose glue
★ hand-made paper card
★ paper lace and ribbon (optional)

1 Tear the white paper into very small pieces and put them into a saucepan. Cover with water and simmer slowly until the paper begins to break down a little. Turn off the heat and allow the mixture to cool.

2 Put the paper with the water into the blender. If you have a hand-held blender, put it into the pan, and switch on at a low speed for a minute. Do not overblend – just mix enough to break the paper. Pour the pulp into a small bowl, or leave it in the saucepan if you have used a hand held blender.

3 With a toothbrush, apply a very thin coat of cooking oil to the surface of the ceramic stamp. Work it in well with the bristles. Wash off any excess oil with soap and warm water. Rinse and towel dry.

Be not forgetful to entertain strangers, for thereby some have entertained angels unawares.

Hebrews 13:2

4 Hold the stamp firmly, with the design face up, over the bowl of pulp. Using the teaspoon, heap the pulp onto the surface and press very firmly with the fingertips to press it into the indented image. Make sure you use enough pulp to overlap the edge of the stamp. The harder you press, the smoother the design will be.

5 Now turn the stamp upside down onto a folded dish towel. Press very firmly again making sure that you also press any excess water out of the pulp which overlaps the edge.

6 Place the stamp face up on a cookie sheet and put into a moderately warm oven (350°F/Gas 4/ 180°C) for 20 minutes, until the paper pulp is dry – check frequently to make sure that the pulp does not turn brown. It must be thoroughly dry in order to be released easily from the stamp. You could also dry the medallions in the sun on a warm day.

7 When the stamp is cool and the pulp is really dry, carefully pull the medallion away from the ceramic surface. If it does not come away easily, then it probably needs a little more drying time.

8 To decorate cards with these medallions, cut out the center of a paper or lace doily. Glue a medallion into the middle so it forms a pretty frame all around the image. Use glue to stick this onto a folded card of hand-made paper, leaving an even border all around.

The smaller card is decorated with a border of pink paper lace. Two small slits have been cut along the inside of the fold in the card and a narrow pink chiffon ribbon has been threaded through and tied in a bow. The larger card has no border, but a white chiffon ribbon has been tied into an extravagant bow again at the top of the card.

STRING OF FELT ANGELS

These brightly colored Angels can be hung from the ceiling or simply tied to a picture hook on the wall. In a child's room you may prefer to add more bells rather than colored beads. Always make sure the thread that holds the string together is at least double or triple thickness to prevent it breaking if it is tugged too roughly. For babies or young children, sew only felt Angels together without beads or bells, to avoid the possibility of swallowing or choking.

MATERIALS
★ tracing paper
★ pencil and paper
★ scissors
★ pins
★ 6 × 6in (15 × 15cm) selection of colored felts for each Angel
★ sewing machine
★ thread in colors contrasting to the felts
★ fabric glue
★ needle and thread
★ 4oz (100g) polyester stuffing
★ fishing line/ strong thread
★ 6in (15cm) ribbon
★ 12 bells
★ 4 large beads
★ fabric paint (optional)
★ embroidery needle and thread (optional)

1 Trace around the template on p.113 and cut this basic Angel shape from your larger scraps of felt. On separate pieces of felt cut out simple shapes for the faces, hands and hair. To make ten Angels you will need to cut out a total of twenty Angel bodies, twenty hands, ten faces and ten hair pieces. Use a mix of colors to make up each Angel.

2 Mark outlines for the dresses onto the reverse side of your tracing template. Place the tracing, right side up, over the felt body pieces and draw over the outlines of each dress – the pencil tracing will mark the felt. In a contrasting thread, follow this outline with a straight stitch on your machine. Decorate the dress outlines with felt trimmings cut from contrasting scraps.

3 Stick on the faces, hands and hair pieces using fabric glue. Paint the faces using fabric paints, or embroider facial features if you prefer. You can also add buttons, beads, or sequins – but notions like these should not be used if the decoration may be hung where a young child could reach it.

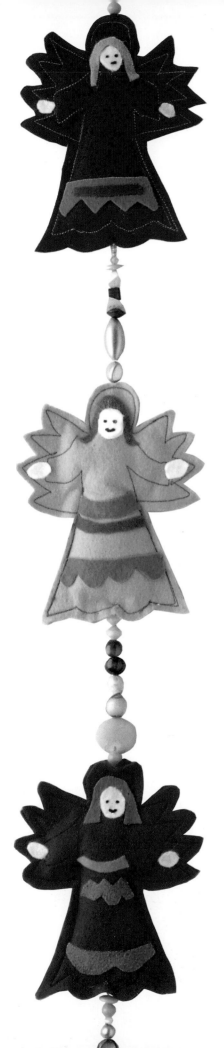

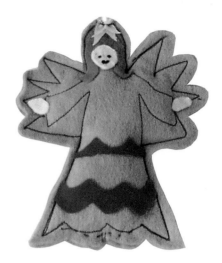

4 Pin two felt Angel shapes together, right sides out. Sew them together, following the outline, using a straight stitch on the machine. Leave a gap of 2in (5cm) at the base of each Angel. To create the sharp points to the wings, you will need to lift up the sewing foot and turn the felt pieces before replacing the foot and continuing to sew a line in the new direction.

5 Gently push a little bit of stuffing through the gap left at the base of each Angel. Use a blunt pencil or end of a paintbrush to stuff the head area. Sew up the base either by machine or hand. Even out the stuffing by flattening each Angel slightly between your hands. Use your fingers until you have a neat shape without any lumps.

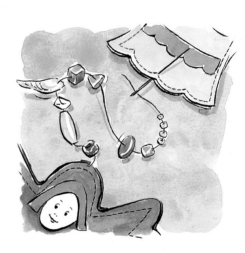

6 Thread 3in (7.5cm) of the fishing line or thread with small beads. Oversew the line onto the top of the first Angel to secure the beading. Pass the line inside the Angel from top to bottom throught the stuffing. Thread on more beads, or other notions, and pass the line through the second Angel. Repeat until all the Angels, and most of the beads are threaded onto the line. Leave 5in (10cm) of line at the end and thread on a few beads. To secure the final beads knot securely or tie a bell to the end.

7 Sew a loop of ribbon onto the top of the line and cover the stitches with a bead. If you have used fabric paint, allow it to dry before hanging the string of Angels from its loop.

TEMPLATE SHOWN HERE AT 50%

MEXICAN ANGEL BOWL

Papier-mâché can be surprisingly strong, particularly after it has been given several coats of hardwearing polyurethane varnish. For tips on how to create papier-mâché items see the Papier-mâché techniques section on pp.28-9.

Papier-mâché bowls can be used to hold whole fruits or dried ingredients such as pot pourri, but you cannot put anything wet in them. To clean papier-mâché, simply wipe with a damp cloth.

MATERIALS

★ ceramic or plastic bowl
★ petroleum jelly
★ paper, cut into strips
★ wallpaper paste
★ bucket for mixing paste
★ white latex paint
★ brushes
★ tracing paper
★ pencil
★ colored tempera paints
★ polyurethane varnish

1 To prevent the mold and your bowl sticking rub a layer of petroleum jelly over the surface of an upturned ceramic or plastic bowl, including the rim if the papier-mâché is to extend this far. For a bowl shallower than its mold, spread the jelly only slightly farther than where you intend to finish the papier-mâché – this will allow you to handle the bowl by the uncoated rim.

2 Apply a preliminary layer of unpasted paper strips to the bowl so that your finished bowl and the mold will separate more easily. Mix up some wallpaper paste. Gradually build up layers of pasted paper strips around the bowl. Allow each layer to dry before adding the next. Build up at least three complete layers. The more layers it has, the thicker and more robust the bowl.

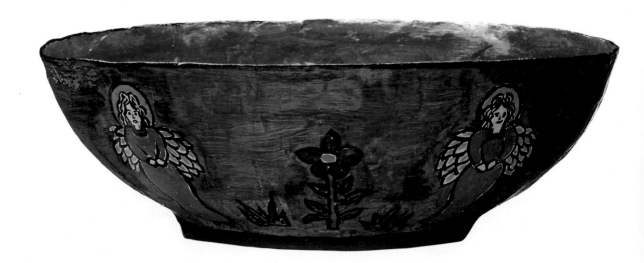

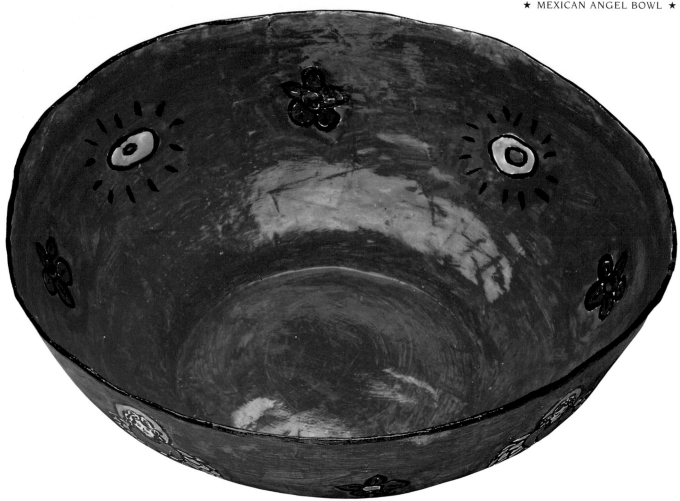

TEMPLATES SHOWN
HERE AT 70%

3 When the last layer of paper strips has completely dried, gently twist the mold away from the papier-mâché. Apply small pasted paper strips around the rim, and inside the bowl to give a neat, even finish. Leave to dry.

4 Paint the bowl inside and out, with two coats of white latex paint, leaving it to dry between coats. Trace the templates on this page or choose your own images. Transfer to the bowl and paint your design with water-based tempera colors. Protect and seal your bowl with at least three coats of polyurethane varnish, leaving it to dry between coats. Leave the bowl to dry completely before use.

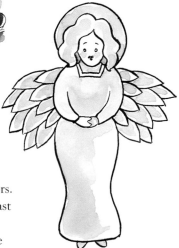

HEAVENLY MOSAIC

Creating mosaics is a lot easier than you might think. It's rather like making a jigsaw. The Mosaics technique section (see pp.32–3) helps to explain the technique in more detail. The equipment needed to get started may be a little costly, but we will almost guarantee that you will be hooked on mosaics once you have finished your first one, and be ready to start another.

MATERIALS

- ★ particleboard
- ★ all-purpose glue
- ★ brush for adhesive
- ★ mixing bowl
- ★ rubber gloves
- ★ gray grout
- ★ cloth
- ★ pencil
- ★ saw
- ★ mosaic tesserae
- ★ tile nippers

1 Cut a piece of particleboard to the required size, or look for an off-cut at your local lumber store. Brush the flat surfaces with a dilute solution of all-purpose glue (see p.32). When the glue has dried, draw the Angel outline onto the surface of the particleboard, you could use our design below. Draw a simple oval face and mark in the eyes, nose and mouth.

2 Next draw in the wings. Do not worry about adding too much detail at this stage, as this can be restricting when you are snipping the mosaic pieces to fit. It is easier if you fill in the details of the mosaic as you are working on it. Use the saw teeth to scratch the surface of the particleboard. Parts of the drawing may be lost but it is possible to draw these in afterwards, if necessary.

3 Assemble the mosaic tesserae together and select the colors you will be using for the face section. Start to cut the pieces of mosaic using the nippers, and follow the method described on p.33 (Step 4). Place the tiles on to the surface of the particleboard using a little all-purpose glue to secure each piece (woodwork glue will work equally well). Slowly build up your picture, working from the center outwards. Butt each mosaic piece as closely as you can to the adjoining pieces, nipping away parts of each tile to fit the space.

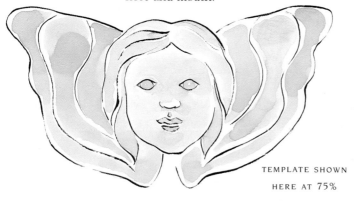

TEMPLATE SHOWN
HERE AT 75%

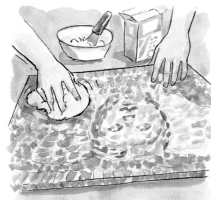

4 When the mosaic picture is completed, mix a small amount of gray-colored grout with water in the mixing bowl to make a thick paste. Wearing protective rubber gloves, use your fingers to spread the grout over the mosaic, pressing it between the gaps. With a damp cloth, wipe away the excess. Allow to dry. A dusty layer will form over the surface but this is easily wiped away with a damp cloth, once the grout has dried.

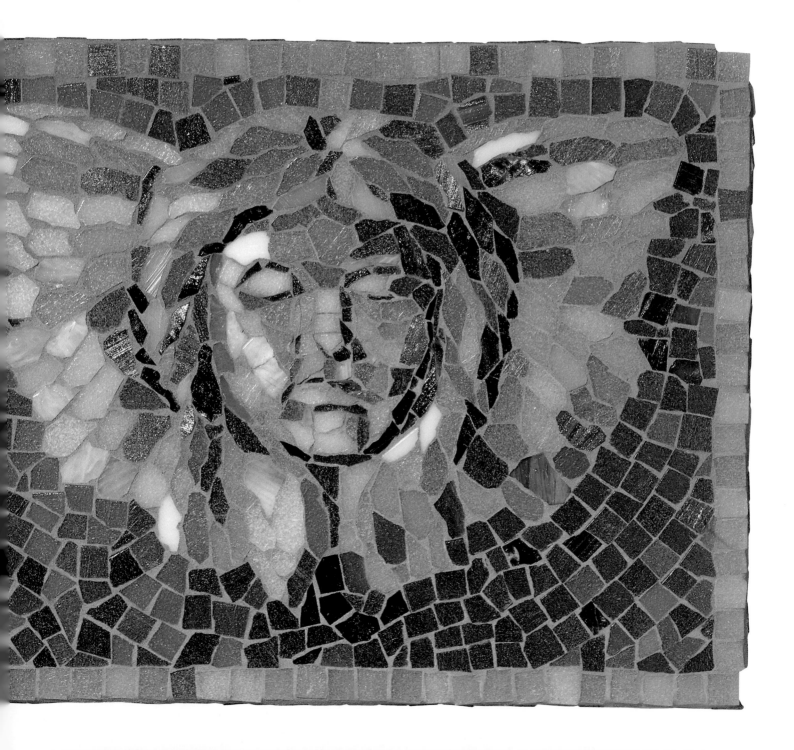

ANGEL WINGS

These organza wings have elastic hoops for use as shoulder straps to secure the wings onto a child's back. The double layer of shimmering fabric is delicately beaded and decorated with sequins and lace for a perfect gossamer flight of fancy. Elongated beads are sewn into sparkling star patterns on the wings, contributing to the heavenly image of an Angel.

MATERIALS
★ cotton gloves
★ 102in (260cm) wire (coat hanger thickness).
★ pliers
★ masking tape
★ two pieces of 3 × 2in (7.5 × 5cm) white felt
★ scissors
★ needle
★ 40 × 40in (1 × 1m) white organza
★ thread
★ pinking shears
★ sewing machine
★ 24in (60cm) narrow elastic
★ 50 approx. white or silver sequins
★ 50 approx. silver round and elongated beads
★ 120in (3m) white lace
★ white fabric paint (optional)

1 Put on a pair of cotton gloves to protect your hands from getting scratched. Snip two lengths of wire approximately 51in (130cm) long, using the cutting edge of a pair of pliers. Overlap the two cut ends of one wire by approximately 3in (7.5cm). Twist the ends of the wire to make a hoop. Bind the ends securely with masking tape, ensuring that you cover any sharp points. Repeat with the other wire.

2 When you have shaped the wire into two separate hoops, start to pull each of them into the shape of a wing. Keep the twisted wire at the base of each wing, and hold onto this as you pull the wire outwards. Bend the wire with your fingers, until it makes an elongated shape with a slight indentation on the underside of each wing. The wire is easy to bend and will hold its shape.

3 Cut two pieces of white felt 3 × 2in (7.5 × 5cm) to form the central pocket into which the base of each wing will be stitched. Hold the two wings together at the twisted sections. Place one piece of felt over the join and the other under it, sandwiching the twisted wire inside. Hand stitch the felt pocket securely around the wire.

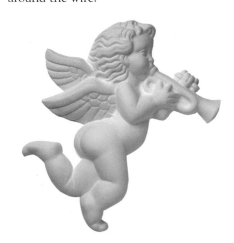

4 Using the wings as a guide, cut a double thickness of white organza fabric for each wing, allowing an extra ³/₄in (1.5cm) all round for the seam. Cut with pinking shears to minimize the risk of fraying. Sew the organza pieces together using a line stitch on your machine, leaving a 12in (30cm) gap at the base for turning right side out and fitting wire.

5 Turn the right sides of the organza out and fit the fabric over the wire. You will need to squeeze the wire a little to fit through the opening, but you can re-shape the wing once the wire frame is inside. Sew up the gap at the base of each wing, neatly tucking any raw edges into the felt pocket.

6 Sew a line of stitches as close as possible to the inside edges of the wings to prevent the organza slipping.

7 Sew two 12in (30cm) hoops of elastic onto the center of the inner piece of white felt.

8 Decorate the organza on the wings with sequins, silver beads and, if you wish, tiny dots of white fabric paint. For an especially pretty effect, stitch elongated silver beads into star shapes.

Add to the pretty effect by sewing lace to the edges of both wings to help cover the seams and the wire frames.

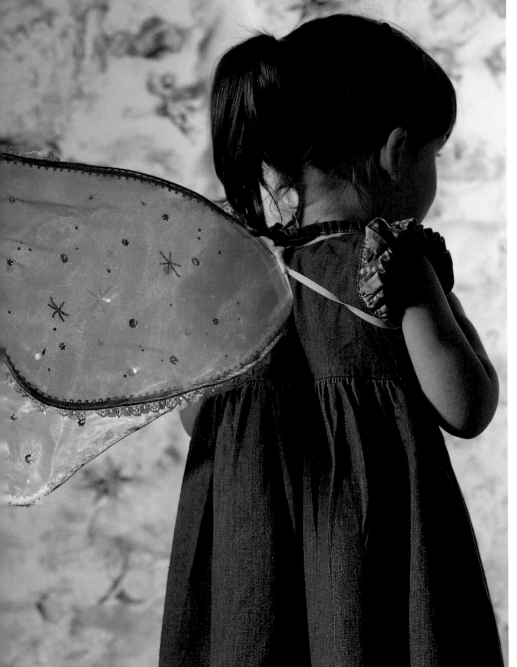

Angels can fly because they take themselves lightly.

G.K. Chesterton

PAINTED PILLOW

For this pillow you could either use a ready-made, plain cover, or make your own. Fabric paints are simple to use and their colors are often vibrant, making an eye-catching design to brighten up a tired chair or to scatter over a bed.

MATERIALS

★ plain ready-made pillow cover or cotton fabric to make your own
★ pillow pad – size to fit ready-made cover or your own cover
★ scissors
★ tape measure
★ needle and thread
★ sewing machine
★ iron
★ white chalk and ruler
★ pencil
★ artist's brushes
★ fabric paints
★ protective cotton cloth

1 If you are making up your own cover, place the pillow pad on a single thickness of the cotton material and cut out a square to fit the pad – remember to add an extra 1in (2.5cm) all around for a seam allowance.

Cut out a second piece for the back. The width will be the same as the front piece, but the length should be one and three quarters the length of the front. Cut this piece in half across its width – turn these cut edges under and hem using a sewing machine.

Lay these two back pieces on top of the front piece, with the right sides together and the outer edges aligning. The hemmed edges of the back pieces are supposed to overlap in the center to create a slot for the pillow pad to fit through. Pin and machine stitch the outer edges of all the pieces together.

2 Iron the front cover in half across its width. Open it out, then iron in half across the length so you have four squares. If your cover does not hold creases well, lightly mark these sections using a piece of white chalk and a ruler. Do not use a pencil as the marks will be difficult to remove and will spoil the finished effect.

3 Mark in the positions of the scallops using a light pencil mark. The fabric paint will cover these marks but try to keep them as faint as possible nonetheless. The scallops do not need to be uniform – the hand-painted look is often enhanced by slight irregularities. Paint along the lines using a narrow brush and colored fabric paint. Leave to dry.

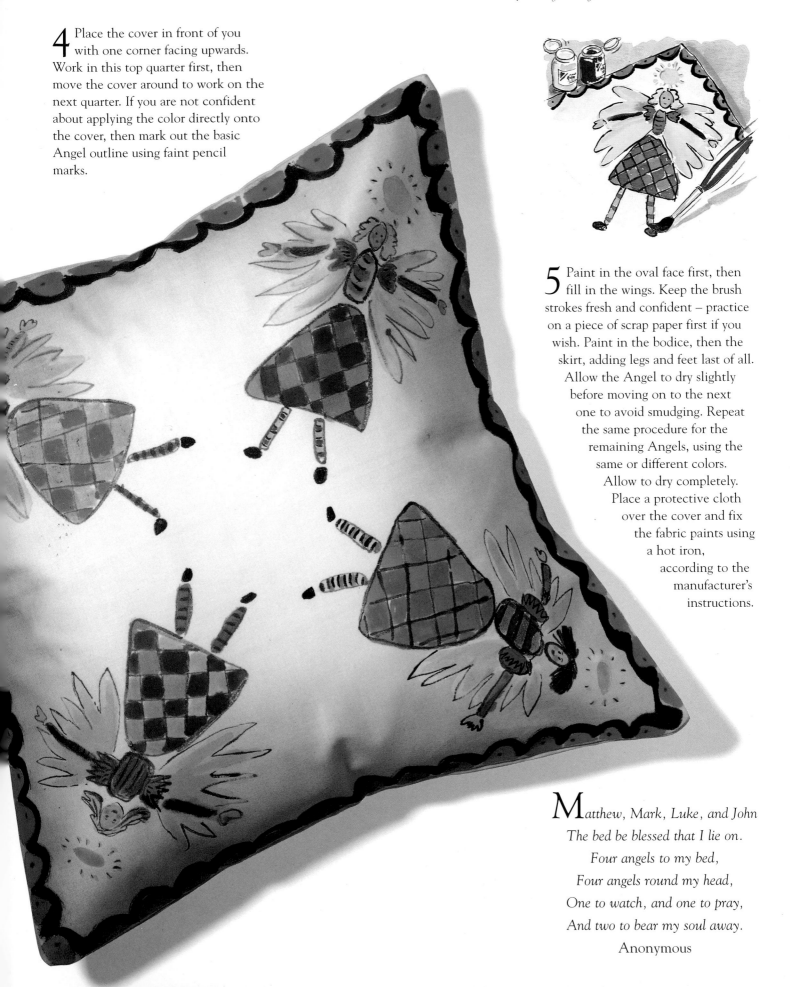

4 Place the cover in front of you with one corner facing upwards. Work in this top quarter first, then move the cover around to work on the next quarter. If you are not confident about applying the color directly onto the cover, then mark out the basic Angel outline using faint pencil marks.

5 Paint in the oval face first, then fill in the wings. Keep the brush strokes fresh and confident – practice on a piece of scrap paper first if you wish. Paint in the bodice, then the skirt, adding legs and feet last of all. Allow the Angel to dry slightly before moving on to the next one to avoid smudging. Repeat the same procedure for the remaining Angels, using the same or different colors. Allow to dry completely. Place a protective cloth over the cover and fix the fabric paints using a hot iron, according to the manufacturer's instructions.

M atthew, Mark, Luke, and John
The bed be blessed that I lie on.
Four angels to my bed,
Four angels round my head,
One to watch, and one to pray,
And two to bear my soul away.

Anonymous

DÉCOUPAGE INSPIRATIONS

Use this selection of Angels for your
découpage images or as photocopied
outlines to decorate and create your own
heavenly craft projects.

Cherubim

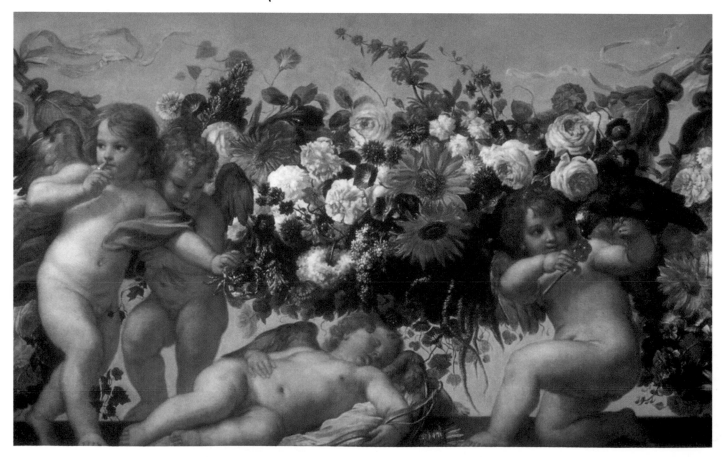

Angels

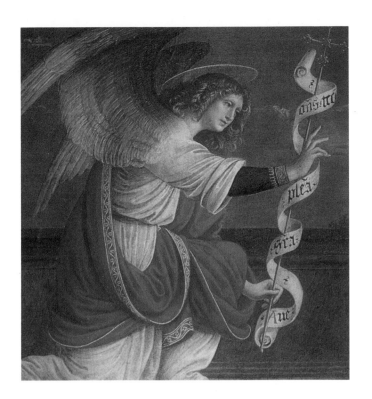

Heavenly Bodies

a b c d e f g h i j k l m

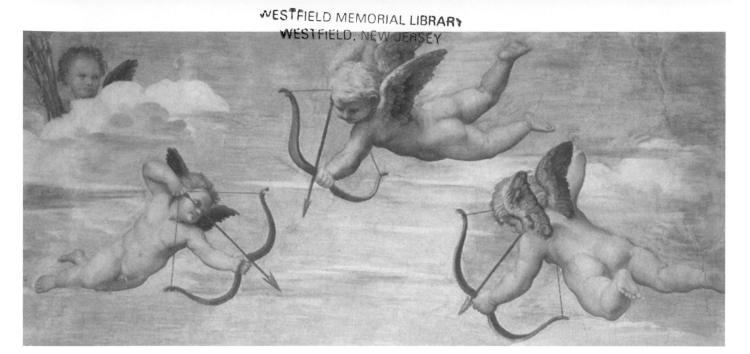

Angels

n o p q r s t u v w x y z

INDEX

All techniques and working methods
are illustrated.
Page numbers in *italics* refer to
photographs of paintings and finished
projects.

CREDITS

The author and publisher would like to thank the following for allowing the use of their images in this book:

Pages 16 & 17: Courtesy of Visual Arts Library, London. All other paintings shown in this book are courtesy of Planet Art, California, USA.

All other photographs are the copyright of Quarto Inc.

Quarto Publishing would like to thank the following for supplying their product for use in demonstrations in this book:

Wimpole Street Creations (*Lace Angel* page 63-65); Designs for the Needle, Inc (*Cross Stitch Angel* page 81-83); and Rycraft Inc. (*Paper-Cast Angel Medallions*).

Designs for the Needle Inc.,
2918 Southwest Boulevard,
Kansas City,
Misssouri 64106, USA
Tel: (816)753 4005

Rycraft Inc.,
4205 SW 53rd Street,
Corvallis
Oregon 97333, USA
Tel: (541)753 6707

Wimpole Street Creations
Barrett House, PO Box 5840505
North Salt Lake,
Utah 84054-0585

Terminology translations

US terms	-	UK & Australian terms
all-purpose flour	-	plain flour
all-purpose craft glue	-	PVA
batting	-	wadding
cluny doily	-	round lace doilie
denatured alcohol	-	methylated spirits
gauze/cheesecloth	-	muslin
latex paint	-	emulsion paint
muslin	-	calico
particleboard	-	medium density fibreboard (MDF)
pillow form	-	pillow pad